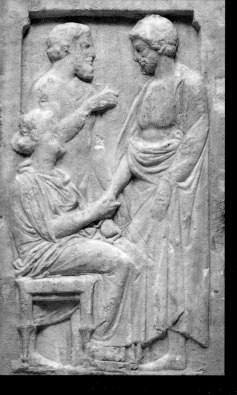

LOOKING AT GREEK AND ROMAN

SCULPTURE IN STONE

LOOKING AT

GREEK AND ROMAN
SCULPTURE IN STONE

A GUIDE TO TERMS, STYLES, AND TECHNIQUES

JANET BURNETT GROSSMAN

THE J. PAUL GETTY MUSEUM

LOS ANGELES

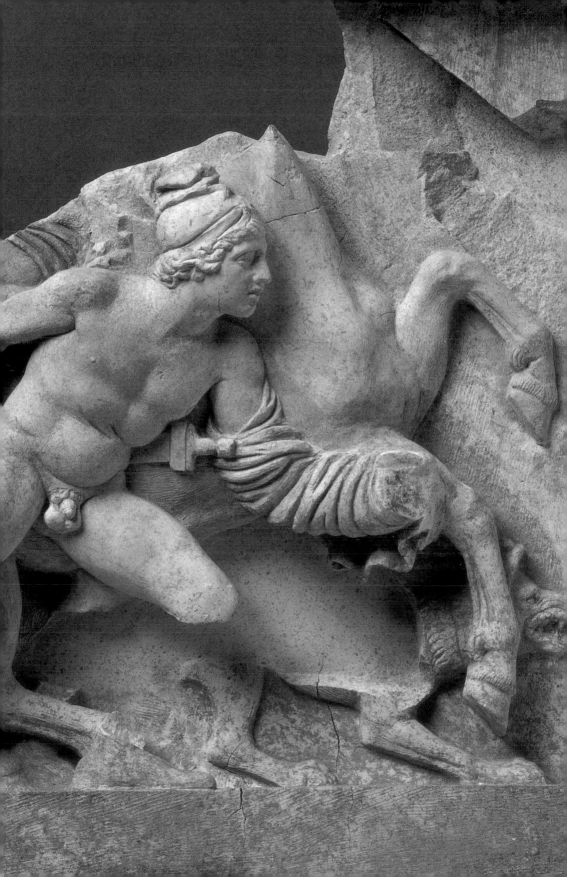

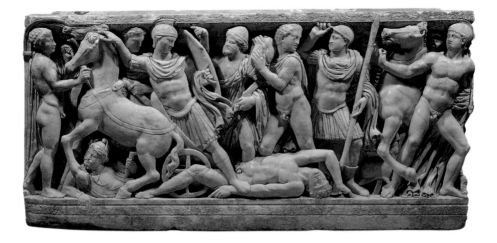

NOTE TO THE READER

Female and male garment types (CHITON, CHLAMYS, DIPLAX, HIMATION, KANDYS, PALLA, PEPLOS, STOLA, TEBENNA, TOGA, and TUNICS) defined in the text are diagrammed in the Chart of Greek and Roman Garment Types beginning on page 116.

© 2003 J. Paul Getty Trust

Getty Publications
1200 Getty Center Drive
Suite 500
Los Angeles, California 90049-1682

www.getty.edu

Christopher Hudson, *Publisher*
Mark Greenberg, *Editor in Chief*

Library of Congress Cataloging-in-Publication Data

Grossman, Janet Burnett, 1943–
 Looking at Greek and Roman sculpture in stone : a guide
to terms, styles, and techniques / Janet Burnett Grossman.
 p. cm.
 ISBN 0-89236-708-3 (pbk.)
 1. Sculpture, Classical I. Title
NB85.G76 2003
733—dc21

2003005581

Front cover: Statue of Venus, detail (see p. 29)

Half-title page: Grave stele, detail (see p. 100)

Frontispiece: Funerary relief (see p. 104)

Back cover: Cycladic harp player, detail (see p. xiv)

Above: Sarcophagus depicting Achilles Preparing to
Drag the Body of Hektor. Marble. Roman, ca.
A.D. 180–220. JPGM 95.AA.80

Colophon: Statuette of a Sleeping Cupid. Marble.
Roman, ca. A.D. 50–100. JPGM 73.AA.95

Contents

Preface

The daily life of an individual in ancient Greece or Rome was one surrounded by sculpted images. Statues and sculpted surfaces were prominently on display in the ancient landscape. Temples and public buildings were decorated with sculpture. Sculptures produced by the Greeks and Romans usually had specific purposes and functions and were not made as works of art in the modern sense. Some were made to commemorate athletic victories and dedicated in sanctuaries. Portraits were sculpted of rulers, nobility, philosophers, priests, priestesses, and politicians. Statues of gods and goddesses were produced in all sizes, from elaborate, monumental cult figures made as dedications in temples, sanctuaries, and shrines, to small images for household or personal dedication or devotion. Grave markers, sarcophagi, and altars for sacrifices were frequently sculpted in relief; sarcophagi often bore portraits of the deceased. Certainly the sculptors and craftsmen who produced this sculpted landscape were necessary and important members of society; it is interesting that they were often considered of low status.

Most books on Greek and Roman sculpture focus on the subjects, iconography, style, function, and aesthetics of the craft. Placing extant sculptures within a chronological scheme is of importance to many scholars, as is attributing a statue or relief to the sculptor who created the work and whose name might be known from ancient literature, an inscription on a statue's base, or from the sculpture itself. In order to thoroughly understand and appreciate ancient stone sculptures, however, one should also understand the materials, techniques, and tools used to produce them—the purpose of this volume.

Material analysis by scientific and technical means may contribute information about a particular statue or relief. Determining the provenance of a stone may give an approximate date of the fabrication of a sculpture, information on trading patterns, and insight into changing aesthetic tastes, and may also shed light on authenticity. The technical differences in the treatment of various stones have a major effect on the style and character of a finished sculpture: The sculptor's handling of a particular material may more significantly influence the appearance of the statue than his aesthetic decisions. A study of the manner in which a sculpture was made may help date and, in some cases, authenticate the work.

Most information about these technical processes is revealed by the close observation and study of ancient sculptures themselves. While some of this information is found in both ancient literature and inscriptions, it is often either incomplete, or the ancient terminology is unclear to the modern reader. Few rep-

resentations of ancient sculptors at work, which would add to our knowledge, exist. While there are some similarities between ancient and modern methods of producing sculpture, many features are exclusively the sign of the ancient master sculptor, apprentice, or craftsman who relied on hand tools and muscle power. Tool marks left on a sculpture's surface and joins attaching one part of a sculpture to another—when submitted to detailed visual examination—contribute immeasurably to our understanding of ancient sculptural production. Greek and Roman sculptors used similar media for their respective statuary—marble, limestone, and other stones—and their tools and techniques were similar. There were, however, some carving techniques that seem to have been Roman innovations (e.g., a different spatial approach to depicting figures on a relief). Study of unfinished sculptures found in archaeological contexts has been an extremely valuable resource for information about the working methods of ancient sculptors. An important difference has come to light by this means: The Greek practice was to work a block of marble from all sides at a more or less even rate, whereas unfinished statuary from Roman sculptors' workshops show that designs were drawn directly on the stone and then carved from front to back.

This book is a glossary of the terms commonly used to discuss sculpture in general, but in particular Greek and Roman stone sculpture. Many of these terms are used by the scholars whose professional aim is to more fully understand and explain the subject, but the terms should prove valuable to the lay person reading a label or catalogue that accompanies a museum's sculptural collection. Although the scope of the book is specifically limited to reflect mostly details found among Greek and Roman sculptures in the collection of the J. Paul Getty Museum—and the collection is the basis for most of the illustrations in this book—the terms apply more broadly to works found in collections around the world. Some art-historical terms have been included because they are commonly used in discussions on technique or to describe aspects of sculptures; these should, therefore, prove useful to the general reader. Many entries contain words or phrases in small capital letters; these are cross-references to other related entries in the book and are intended to aid the reader.

As with any book, thanks are due to various individuals and institutions. Certain terms were best illustrated by sculptures in collections other than the Getty Museum. I am grateful to the institutions that so generously supplied photographs. My heartfelt gratitude goes to the Getty Museum's Curator of Antiquities, Marion True, for her support and assistance with the project. I especially wish to thank my colleague in the Department of Antiquities Conservation, Jeffrey P. Maish, for his preliminary review of the text and the many valuable

suggestions he offered, which greatly helped clarify many of the technical and scientific terms. Finally, I want to thank my former teachers in the Conservation Center of New York University's Institute of Fine Arts. Even though I was from the art-history side of the graduate program, I was indoctrinated early on in my studies with the absolute necessity of learning about and understanding the technical and scientific aspects of works of art. To one of those teachers in particular—Norbert S. Baer—I dedicate this book.

J. G.

Chronology

For the early prehistoric era in the Mediterranean region, modern scholarship has divided history into chronological periods. These divisions indicate technological or artistic innovations that can often be linked to historical events whose dates are known. The absolute dates given in years for the prehistoric period, however, are not meant to be exact, only approximate.

Neolithic	6000–3000 B.C.
Chalcolithic	3900–2500 B.C.
Bronze Age	3600–1050 B.C.
Cycladic	3200–1000 B.C.
Minoan	3000–1000 B.C.
Mycenaean	1600–1000 B.C.
Iron Age	1050–900 B.C.
Geometric	900–700 B.C.
Orientalizing	750–650 B.C.
Daedalic	700–600 B.C.
Archaic	700–480 B.C.
Classical	480–323 B.C.
Early Classical	480–450 B.C.
Late Classical	380–323 B.C.
Hellenistic	323–31 B.C.
Republican Rome	509–27 B.C.
Augustan	27 B.C.–A.D. 14
Julio-Claudian	A.D. 14–68
Flavian	A.D. 69–96
Trajanic	A.D. 98–117
Hadrianic	A.D. 117–138
Antonine	A.D. 138–193
Severan	A.D. 193–235
Late Roman	A.D. 235–330

Abbreviations

cf.	compare
cm	centimeter
DAI	Deutsches Archäologisches Institut
Diam	diameter
e.g.	for instance
H	height
in.	inch
JPGM	The J. Paul Getty Museum
kg	kilogram
L	length
neg. no.	negative number
pl.	plural
r.	ruled
RMN	Réunion des Musées Nationaux

Correspondence of Greek and Roman Mythological Names

Greek	Roman
Aktaion	Actaeon
Aphrodite	Venus
Apollo	Apollo
Artemis	Diana
Athena	Minerva
Dionysos	Bacchus
Herakles	Hercules
Isis	Isis
Kybele	Cybele
Leda	Leda
Marsyas	Marsyas
Zeus	Jupiter

Black Sea

ASIA
MINOR

PHRYGIA

Ankara

Docimium
Afyon

Aphrodisias

Cremna

Antioch

CYPRUS

North

EGYPT

Alexandria

| 0 | | | | 100 miles |
| 0 | | | | 150 kilometers |

Abrasion

Harp Player (detail). Cycladic, about 2500 B.C. Marble. JPGM 85.AA.103
During the BRONZE AGE sculptors on the CYCLADIC Islands used primarily abrasion to form their sculptures.
The fine network of shallow lines on the surface of this STATUE was created by abrasive action.

Glossary

ABRASION

A process used to produce a smooth, POLISHED finish on stone. Abrasives such as EMERY, PUMICE, or SANDSTONE were rubbed against the sculptural surface, probably either in the form of powder worked by pieces of fabric or leather or shaped into a hand-held form.

ACANTHUS

A leaf motif used extensively on Greek and Roman sculpture. The design and the name are taken from a prickly herbaceous plant that is still widespread in the Mediterranean area. While acanthus leaves are seen most frequently in architectural decoration, especially on the capitals of Corinthian columns, they are also commonly seen in the design of the crowning elements (ANTHEMIA) of grave markers.

Acanthus
Anthemion
Greek, about 320 B.C.
Marble with polychromy
H: 76 cm (29⅞ in.)
JPGM 79.AA.18
The design of this
ANTHEMION from a
gravestone is based
in part on the broad,
curly-edged leaves of
the acanthus plant, seen
most clearly in the lower
area on the right.

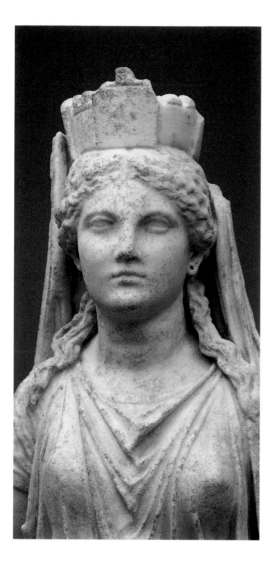

Accessories
Statue of Tyche (details, front and
rear views)
Greek, about 100 B.C.
Marble. JPGM 96.AA.49
Holes were DRILLED in the ears and
through the back of the veil to secure
separately made metal earrings and
a necklace. Photo: Bruce White.

ACCESSORIES

Marble sculptures sometimes had certain features made in other materials.
Eyeballs, for instance, although generally painted on a smoothed surface, were
occasionally made of ivory, stone, and/or glass and then inset. Metal jewelry
adorned STATUES of woman and goddesses; it was attached to holes specially
DRILLED to secure the pieces. See also ATTACHMENTS, ATTRIBUTES, INLAYS.

ACROLITH

A STATUE with its extremities and head made from marble or another stone and the body from wood. Acrolith is a Greek word meaning "with extremities of stone." This type of statue was produced where cost and availability of materials were factors. In areas where there were no native sources, marble was costly since it had to be imported and was therefore reserved for the principal or visible parts of a figure that represented the flesh. The wooden bodies of some acroliths were covered with a layer of gold foil.

A variation on this technique—used especially in the Greek colonies of South Italy and Sicily because all marble there was imported from Aegean QUARRIES—was to make the clothed part of the statue in LIMESTONE and the extremities in marble.

Acrolith
Acrolithic head
of Athena
Greek, about 425 B.C.
Marble
H: 21 cm (8¼ in.)
JPGM 82.AA.91
Only this marble head
survives from an
acrolithic STATUE of
Athena. Holes and
ATTACHMENT cuttings
in the head indicate
the places where parts
made of other materials
were fastened to
complete the figure.

Acroterion (pl. acroteria)

A decorative element placed at the apex and corners of a pitched roof. As architectural features, either figural or floral in design, acroteria could be quite large and elaborate on actual buildings. The same elements are also found on smaller monuments crowned by PEDIMENTAL forms, such as funerary or inscribed decree STELAI.

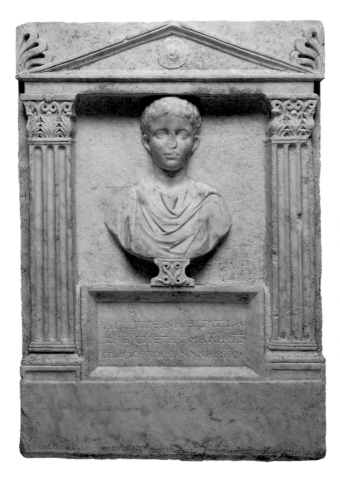

Acroterion
Grave Relief of Agrippina
Roman, about
A.D. 150
Marble
H: 77.5 cm (30½ in.)
JPGM 71.AA.456
The figure of the deceased on this grave RELIEF is framed by fluted pilasters with Corinthian capitals supporting a PEDIMENT. The acroteria on the corners of the pediment are carved in the shape of palmettes. Photo: Jack Ross.

Adhesive

Glues and cements were used to assist in JOINING parts of a sculpture, to affix ATTACHMENTS and ACCESSORIES, and in LEAF GILDING. Analyses of adhesive remains have revealed several different mixtures, including those created from lime, beeswax, lead oxide, and resins. Resin is mentioned by PLINY (*Natural History* 33.94) as an adhesive for marble. Organic adhesives such

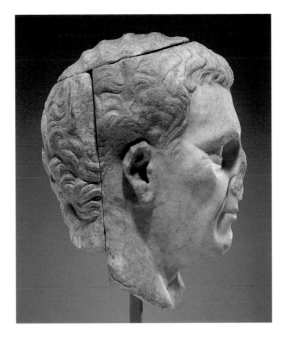

as animal glues, milk, blood, or albumin from egg white are known to have been used (Pliny *Natural History* 33.64), but have not survived the burial conditions in which most sculptures have been found. See also PIECING, WAX.

AFRICANO MARBLE

A multicolored marble (Latin, *luculleum*) with red, green, white, gray, and pink patches against a black, grayish, or dark green matrix. It comes from a QUARRY located in modern Turkey near the city of Teos (on the coast southwest of Izmir). This colorful marble, very popular in the Roman period for architecture, was used for the columns of the Basilica Aemilia and in the Forum of Augustus in Rome. It was also used for pilasters supporting PORTRAITS, HERMS, and STATUETTES.

AFYON MARBLE

A warm white, small-grained marble (Latin, either *docimium* or *sinnada*) from QUARRIES near Docimium (modern Ischehisar). Spots, clouds, or streaks of gray and yellow frequently occur in this type of marble. The colored marble PAVONAZZETTO comes from the same quarries, often from veins next to the white variety.

ALABASTER

True alabaster is a fine-grained sedimentary stone. It is translucent and generally white, pink, or yellowish with occasional veining or cloudy inclusions. Deposits were QUARRIED in the Nile Valley in Egypt, in North Africa (modern Algeria and Tunisia), and in Asia Minor. It was widely used in Rome as a decorative material in the first century A.D. Softer than marble, alabaster is easier to carve, but water and abrasion easily damage it.

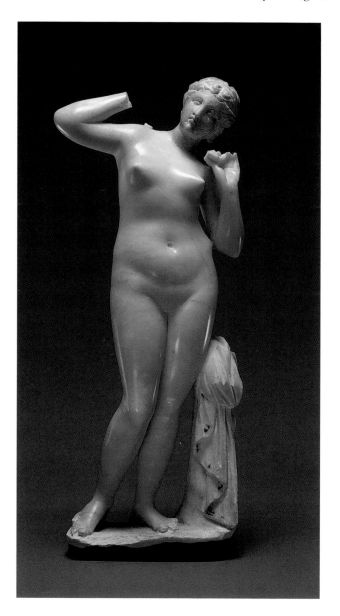

Alabaster
Statuette of Venus
Roman, first
century B.C.
Alabaster with
polychromy
H: 30.5 cm (12 in.)
JPGM 78.AA.6
Alabaster was an
expensive material,
but its creamy hues
suitably display the
soft sexuality of the
body of Venus, the
goddess of love. A
small and intimate
image like this one
was designed for
display in a wealthy
home, probably in a
devotional shrine.

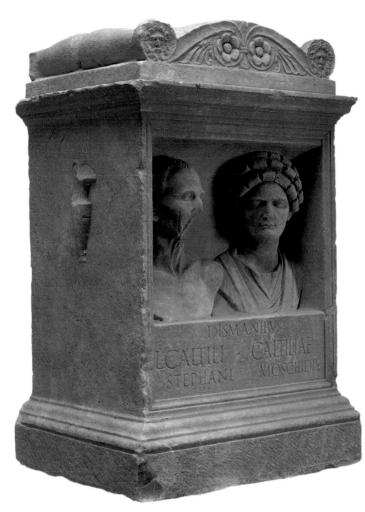

Altar

Funerary Altar of
Caltilius and Caltilia
Roman, A.D. 100–125
Marble
H: 128 cm (50⅜ in.)
JPGM 83.AA.209

PORTRAITS of a
husband and wife
decorate the front of
this Roman funerary
altar. The INSCRIPTION
reads, "To the souls of
the deceased, Lucius
Caltilius Stephanus and
Caltilia Moschis." This
altar is typical of the
funerary monuments
commissioned by freed
slaves, which were
often located in front
of the family tomb—
advertisements to
passersby of the new
social status of the
deceased.

ALTAR

The Greeks and Romans commonly made offerings to their gods on altars—usually round or rectangular structures or monuments, often with side panels that were sculpted in RELIEF. The offerings were frequently burnt; libations were also poured upon altars. Altars were adapted for use as funerary monuments from the HELLENISTIC period onward, but in Rome they were most popular in the first and early second centuries A.D. Many were simple, bearing only an INSCRIPTION, but others were more complex and included sculpted PORTRAITS of the deceased.

ALTERATION LAYER (see WEATHERING LAYER)

Antefix

Fragment of a Grave Stele. Greek, about 350. B.C. Marble. H: 19.5 cm (7⅝ in.). JPGM 73.AA.133
Many CLASSICAL grave markers were carved in the form of a small architectural enclosure with a
flat top lined with antefixes. The peaked structures on the top of this fragment represent
antefixes atop the flat roof of the enclosure.

ANTEFIX

Decorative upright tiles, usually terracotta, that were set along the edges or
eaves of the roofs of Greek, Etruscan, and Roman buildings. Antefixes cov-
ered and protected exposed wooden parts of the architecture from the ele-
ments. They were commonly decorated with stylized plant forms, animals,
masks, or mythological figures that probably had a guardian or magical func-
tion for the protection of the building they adorned.

ANTHEMION (pl. ANTHEMIA)

Carved decorative crowning elements on marble STELAI whose design is
based on simplified leaf and flower forms. A major element of many anthemia
is the palmette, a stylized palm-frond ornament of radiating petals, which is
often combined with the ACANTHUS.

APHRODISIAN MARBLE

A warm white medium- to large-grained marble, which comes from QUAR-
RIES near the ancient site of Aphrodisias in modern southwestern Turkey. The
coloring is usually uniform, although with occasional patches of a light warm
brown as well as small pockets of crystals. Layers of blue-gray marble lie next
to the deposits of white marble in the Aphrodisian quarries and were utilized
together to create certain two-color sculptural compositions. This type of mar-
ble was primarily used from the HELLENISTIC to Late Roman periods.

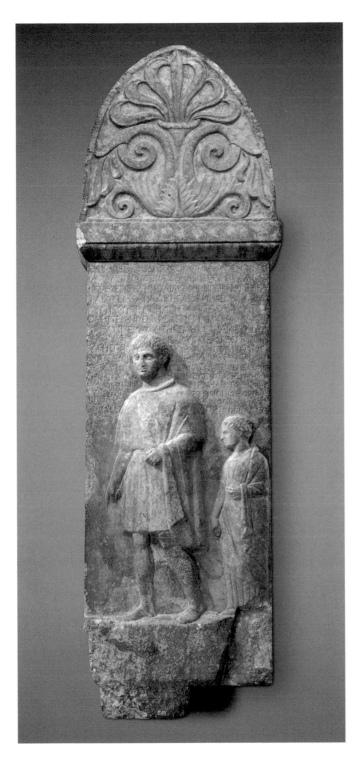

Anthemion
Grave Stele of Poseides
Greek, about 275 B.C.
Marble with
polychromy
H: 172.8 cm (68 in.)
JPGM 79.AE.145
The anthemion on this
grave marker is carved
in a design of a seven-
frond palmette above
two half-palmettes that
spring from ACANTHUS
leaves. The young man
on the left wears a
TUNIC under his
CHLAMYS.

ARCHAIC

The style of art produced in Greece and its colonies in the period from 650 to 480 B.C., exemplified by sculptures of KOUROI and KORAI, is called Archaic. In general, Archaic art is characterized by frontal forms or straight profiles, symmetry, repetition, and geometric abstractions. Surface patterning and geometric forms denote details of anatomy, which were incised into the stone at the beginning of the Archaic period, but were sculpted more naturalistically later.

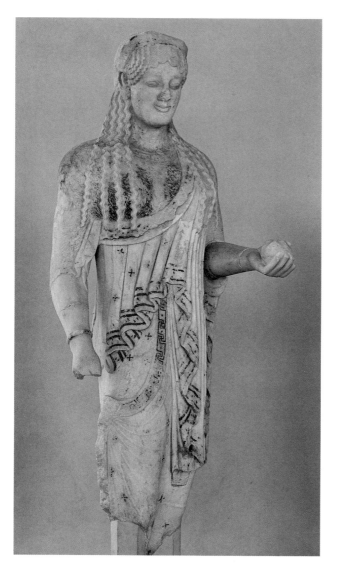

Archaic
Statue of a Kore
Greek, about 530 B.C.
Marble with polychromy
H: 115 cm (45¼ in.)
Athens, Acropolis Museum 680
Characteristic features of STATUES of young women created during the Archaic period include the crimped rows of the hairstyle, the broad face with its calm expression, the style of the clothing, and the erect pose of this KORE. © Scala/Art Resource, NY.

ARCHAISTIC

A term applied to sculpture created after 480 B.C. that intentionally imitated the style of earlier, ARCHAIC art forms. Features such as hairstyles, facial expressions, and postures modeled on Archaic types and styles were used by sculptors of later periods, especially in the Roman period, to create STATUES that blended features and characteristics of both the Archaic and then-contemporary periods.

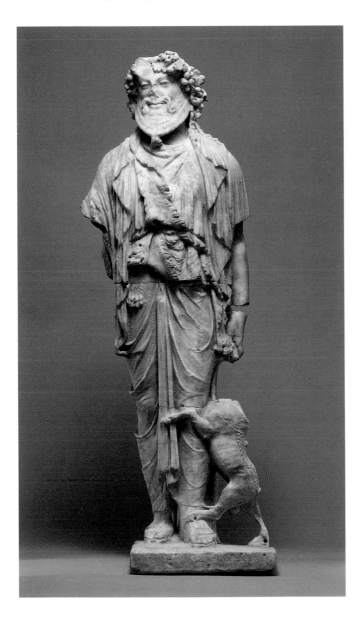

Archaistic
Statuette of Bacchus
Roman, about A.D. 50
Marble
H: 62.3 cm (24½ in.)
JPGM 96.AA.211
The stiff pose, shape of the beard, and the complex series of garment folds on this figure of Bacchus, the god of wine, are typical of art of the ARCHAIC period. Other features, such as the naturalistic rendering of the anatomy, identify the STATUETTE as one carved in the Roman period. The combination of features from these two different time periods identifies the style of the figure as Archaistic.
Photo: Bruce White.

ARGIVE WORKSHOPS

Centers of sculptural production in the Greek city of Argos, active beginning in the eighth century B.C. Specific features, such as compact and sturdy builds with a heavy, square quality and cleanly articulated anatomy, distinguished Argive STATUES of human figures. Many sculptor's names from Argos have been cited in literature or are INSCRIBED on statue BASES found in major sanctuaries, such as Olympia and Delphi, and include: Agelades, Antiphanes, Athenadoros, Atotos, Dionysos, Glaukos, Naukydes, Polymedes, Theodotos, and the most famous Argive sculptor, POLYKLEITOS. See also WORKSHOP.

ATHENIAN WORKSHOPS

The centers of sculptural production in the Greek city of Athens were known for their well-proportioned and balanced STATUES of the human figure. The bodies of these figures are tall and sinewy, with firmly modeled musculature; the faces usually express a calm dignity. Athenian sculptors cited in literature or INSCRIBED on statue BASES include: Alkamenes, Antenor, Endoios, Kalamis, Leochares, Mikon, Myron, PHEIDIAS, and PRAXITELES. See also ATTIC, WORKSHOP.

ATLAS (pl. ATLASES)

Male figure supporting architectural members of a building. In Greek mythology Atlas was a Titan who held the tall pillars that kept earth and heaven apart (Homer *Odyssey* 1.52–54).

ATTACHMENTS

Metal elements affixed to sculptures, attachments could be either functional or purely decorative. Bronze or gold necklaces, earrings, diadems, and wreaths were commonly added. Bronze was fashioned into spears, swords, scepters, and the reins and bridles of horses and frequently attached to sculptures. Holes DRILLED in STATUES and RELIEFS for insertion of the ends of the attachments are often the only indication that a sculpture once had these metal additions. It is speculated that attachments may have been inspired by the practice of putting real clothing and jewelry on wooden statues. Although the tradition continued into Roman times, the peak of this practice occurred during the ARCHAIC period in Greece. See also ACCESSORIES, INLAYS.

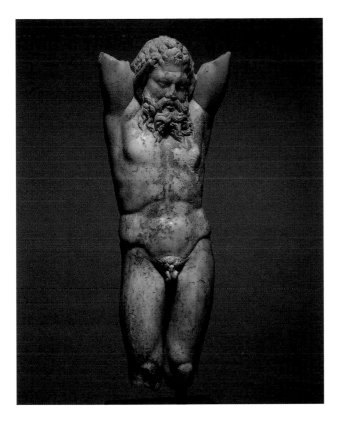

Atlas
Statuette of Hanging
Marsyas
Roman, about
A.D. 200
Marble with gilding
H: 43.2 cm (17 in.)
JPGM 72.AA.107
A small-scale version
of an Atlas, perhaps
this figure of Marsyas
supported a tabletop
on his upraised arms.
Figures of Marsyas—a
satyr who was strung
up and flayed alive
because he dared to
challenge the god of
music, Apollo, to a
flute contest—were
popular in the eastern
part of the Roman
Empire as table
supports.

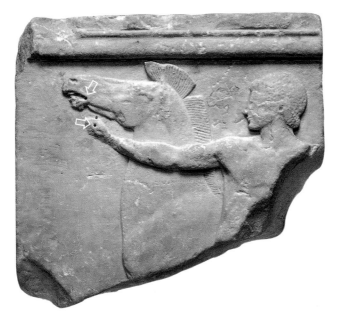

Attachment
Fragment of a Votive
Relief
Greek, about 500 B.C.
Marble
H: 27.5 cm (10⅞ in.)
JPGM 78.AA.59
Bronze reins, the
attachment that would
have clarified the action
of the youth restraining
his spirited horse, were
originally inserted into
the two holes DRILLED
in the horse's mouth
and the youth's hand.

ATTIC

Refers to the region of Attika in ancient Greece, which included Athens and its surrounding territory. Athens and Attika were some of the most prolific centers for the production of sculpture in antiquity, especially from the ARCHAIC through Roman periods. See ATHENIAN WORKSHOPS.

ATTRIBUTES

Often ACCESSORIES or other objects, attributes are visual references that help identify a particular figure. Because relatively few ancient figures can be identified by INSCRIPTIONS, CONTEXT and attributes (e.g., dress, objects carried, accompanying animals, and unique physical appearance) are the usual means of identification. Many gods and goddesses and members of their entourages have particular attributes that identify them. Ancient Greeks and Romans could read attributes just as we easily identify our cultural images today.

ATTRIBUTION

A scholarly process that weighs evidence of date, subject, and certain stylistic characteristics in order to determine whether a sculpture was made by a particular artist, WORKSHOP, or SCHOOL. Much scholarly research has focused on attempting to match surviving Greek and Roman sculptures to one of the Greek or Roman sculptors whose names are either cited in ancient literary sources—especially by PAUSANIAS and PLINY—or INSCRIBED on STATUE BASES.

Because attribution studies rely heavily on stylistic characteristics, which call for subjective judgments, scholars frequently disagree about attributions. Thus the same statue may be attributed to several different sculptors, depending on the opinion of the partcular scholar.

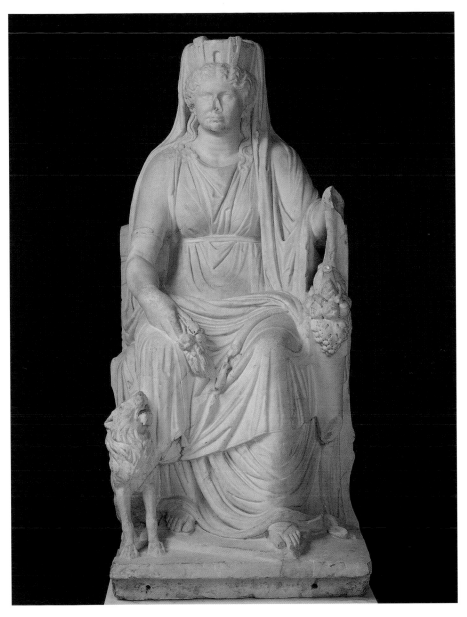

Attributes
Portrait of a Roman Matron as Cybele. Roman, about A.D. 50.
Marble. H: 162 cm (63¾ in.). JPGM 57.AA.19
Found in Rome in the 1500s, this large STATUE of a seated woman portrays Cybele, the great mother-goddess
of Anatolia, whose cult was brought to Rome at the end of the Second Punic War (218–201 B.C.).
Cybele is identified by her many attributes, each signifying one of her different roles: She wears a crown in the
form of a turreted city wall, symbolic of her role as protector of cities; her right hand holds a bunch of wheat
and poppy heads, symbolic of her role as a goddess of agriculture; and her most famous attribute, the lion,
is symbolic of her power over wild animals. Under her left arm she holds additional attributes: the rudder
of Fortune and the cornucopia of Abundance.

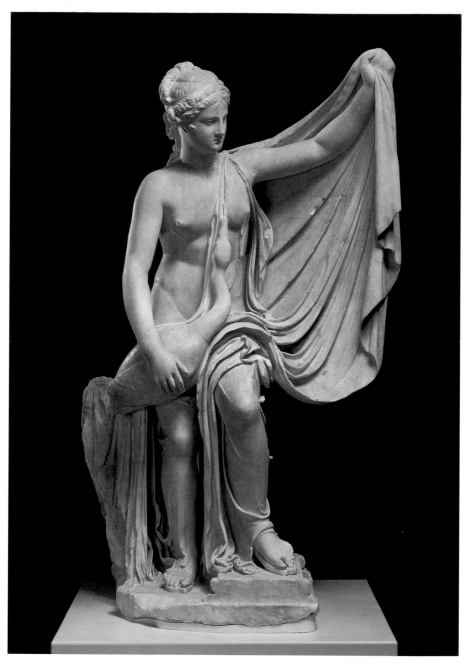

Attribution

Statue of Leda and the Swan. Roman, first century A.D. Marble. H: 132.1 cm (52 in.). JPGM 70.AA.110
Found in 1775 in Rome, this Roman version of an earlier Greek STATUE from the 300s B.C. is
attributed to Timotheos (active 380–350 B.C.); more than two dozen COPIES of this statue survive.
Timotheos favored carving a combination of thin clinging drapery contrasted with heavier folds, the
distinctive element that makes attribution to him possible. Photo: Lou Meluso.

BASALT

A dense, fine-grained igneous rock found in black, brown, and green varieties; it was QUARRIED in Egypt. Basalt was used primarily for figurative sculpture, especially PORTRAITS. The sculptor is limited by the hardness of this stone, and thus basalt sculptures have fewer details. See also WORKING.

BASE

An architectural support, also known as a PEDESTAL, for the display of a completed STATUE. Single statues, large complex groups, STELAI, or RELIEFS were MOUNTED on bases, which were sometimes of an inferior material, such as LIMESTONE. The shape of a base is generally rectangular or round, although it can be triangular or columnar. Bases regularly had a dedicatory INSCRIPTION, and were sometimes SIGNED by the sculptor. Many ancient sculptures are only known only from their inscribed bases, which have survived from antiquity—unlike their statues. Sometimes bases themselves became sculptures with scenes carved in relief on one or more sides. See also PLINTH.

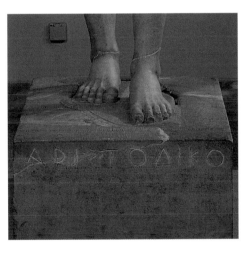

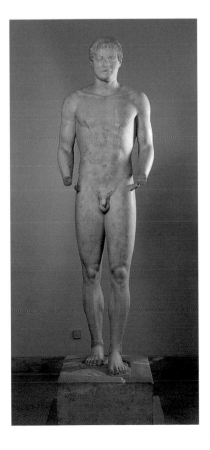

Base
Statue of a Kouros on Its Base
Signed by Aristodıkos
Greek, 510–500 B.C.
Marble
H: 195 cm (76¼ in.)
Athens, National Archaeological Museum 3938.

A rare instance of a STATUE found together with its base. The base is a simple rectangular shape INSCRIBED on the front with the sculptor's name, Aristodikos.

BIGIO ANTICO MARBLE

Characterized by white and gray veins and markings, this dark gray MARBLE with large, brilliant crystals was QUARRIED in various locales along the coast and islands of Asia Minor; the best source was at Teos in modern Turkey. While primarily an architectural stone, it was also used on occasion for large figurative sculpture. Its main period of use was during the Roman era from the mid-first to the mid-third century A.D.

BIGIO MORATO MARBLE

A fine-grained gray MARBLE that was QUARRIED along the coast of Asia Minor, including sites on the islands of Rhodes, Kos, Lesbos, as well as at Teos, Aphrodisias, Mylasa, Ephesos (all in modern Turkey), and at Cape Tainaron in the Peloponnese of Greece. The predominant gray color, which varies in darkness, is sometimes accented with white speckling and markings composed of large and irregularly shaped crystals. The color was especially suited for PORTRAITS of dark-skinned persons and Egyptian gods and followers of their cults. The marble was used by the Romans for statuary in the first through third century A.D.

BINDER

PIGMENT is mixed with a binding material such as egg, wax, bitumen, or honey. Binders such as these hold PIGMENT particles together in suspension and produce paint. Binders also cause paint to adhere to a sculpted surface.

BLOCKING-OUT (see ROUGHING-OUT)

BOLD STYLE (see EARLY CLASSICAL)

BRIDGE

Small marble supports that were purposely left by a sculptor between deeply carved and UNDERCUT elements of a sculpture. Bridges became a feature of certain styles and periods of Roman sculpture.

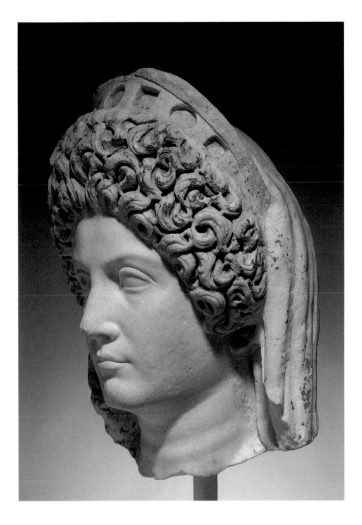

BRONZE AGE

The period in the Mediterranean world from about 3600 to 1050 B.C. Its name is derived from the knowledge and use of bronze by the main cultures of the period, the CYCLADIC, MINOAN, and MYCENAEAN.

BUST

A STATUE of a truncated human figure that became a popular form for POR-TRAITS in the Roman period. A bust features the head and varying lengths of the neck and upper torso, depending on the date of the portrait. For example,

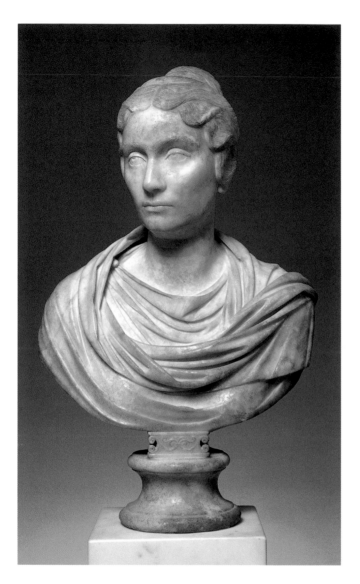

busts carved during the Republic extended to just below the neck, whereas,
by A.D. 100, portrait busts regularly included not only the shoulders but also
the tops of the upper arms, with the lower edge following the contours of the
pectoral muscles. The shoulders and chest on a bust may be nude or clothed;
if clothed, the bust may include an ATTRIBUTE, symbolic of the identity or so-
cial status of the figure represented. See also IDEALISTIC, VERISTIC.

Canon

A system of rules or standards by which the human figure is rendered. In Greek sculpture the Canon refers to a system of PROPORTIONS for carving a figure developed by the sculptor POLYKLEITOS (Pliny *Natural History* 34.55 – 56): Each part of the body related proportionally to an adjacent part. For the Greeks, a STATUE sculpted according to the Canon was a visualization of the values of truth, beauty, and goodness. No original statue by Polykleitos has survived, but there is archaeological evidence that the Romans took plaster casts from statues of his or of the Polykleitan SCHOOL to produce their own versions. The Roman COPIES of the Polykleitan bodies were constructed in an architectural manner, assembling parts like building blocks. According to literary accounts, the Romans valued Polykleitan statuary for its rational proportions and equated the figures with beauty and health (Galen *On the Doctrines of Hippocrates and Plato* 5.3.15–25).

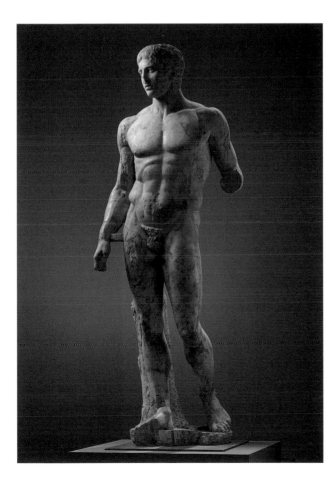

Canon
Doryphoros
Roman, about
A.D. 100
Pentelic marble
H: 196 cm (77⅛ in.)
Minneapolis, The
Minneapolis Institute
of Arts 86.6
The STATUE of a man
carrying a spear, the
Doryphoros was the
embodiment of the
Canon by POLYKLEITOS
according to ancient
writers. Roman
sculptors carved many
COPIES and variants of
the Greek statue, which
was cast in bronze, but
did not survive. Photo:
The Minneapolis
Institute of Arts.

CAPSA

A box for the upright storage of book rolls or scrolls. Scrolls were formed from papyrus sheets that were overlapped and pasted together to form a long roll that wound around a wooden or ivory rod. A capsa was commonly included as an ATTRIBUTE with PORTRAIT STATUES of notable Romans as an indication of a learned nature.

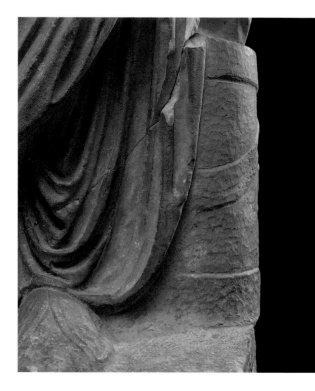

Capsa
Statue of a Togatus
(detail)
Roman, A.D. 150–200
Marble
JPGM 79.AA.77
On the right, behind the man's left foot, partially hidden under the folds of his toga, a capsa rests on the PLINTH. The inclusion of the capsa with the STATUE indicates that the man portrayed here wished to be seen as well read. (See also illustration for TOGATUS, p. 106.)

CARRARA MARBLE

MARBLE QUARRIED in the Carrara district (ancient Luna) in Apuania, Italy. Called *lunense* or *luniense* (Pliny *Natural History* 36.14 and 36.48) by the Romans, it has a fine, compact grain of medium hardness with very small crystals, and ranges in color from creamy to snow-white, sometimes with a bluish tinge. Occasionally large flecks of black or brown color interfere with its usefulness for sculpture. Carrara has been a major source of marble for sculptors since at least the late first century B.C. While it appears that the Etruscans used the quarries for locally produced sculpture, perhaps as early as the third century B.C., the main period of operation was from the 50s B.C. through the third century A.D.

CARVING

Sculptures made of wood, ivory, amber, or stone are formed by cutting and shaping with a variety of carving TOOLS, including CHISELS of various types, RASPS, and DRILLS. The stages of carving or sculpting a three-dimensional figure from a single block of material are: (1) sketch or INCISE the profile of the intended figure on the opposite sides of the block and partially carve the profile; (2) sketch or incise the front view on the front of the block and partially carve this view and cut out the interior spaces (such as between arms and legs); (3) partially smooth the figure; (4) define the musculature and clothing and carve the hairstyles and facial features; and (5) finish the figure with INCISED surface details and surface POLISHING.

CARYATID

A column carved in the shape of a female figure that is used to support the upper parts of a CLASSICAL building. The Greek word was derived from Caryae in Lakonia where maidens performed ritual dances at a festival of Artemis (Pausanias *Description of Greece* 3.10.7). The architectural figures are maidens dressed in long robes. Male supporting figures are called ATLASES.

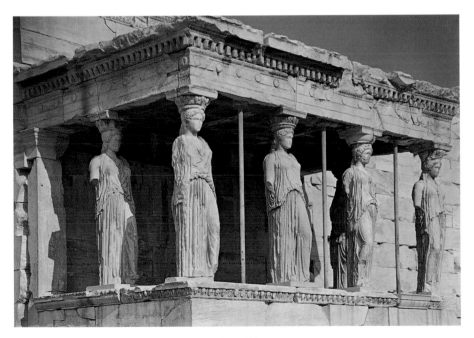

Caryatid
Caryatids. Greek (Athenian Acropolis, Erechtheion), 420–410 B.C. Marble. H: 231 cm (91 in.).
Sculpted in the shape of young women, these caryatids are carved to support the roof of the south porch of the Erechtheion, a small temple on the Acropolis in Athens. © Scala/Art Resource, NY.

CHISELS (see CLAW CHISEL, CURVED CHISEL, FLAT CHISEL, TOOLS)

CHITON

A Greek dress of thin fabric, either linen or silk, that was worn by both men and women. Frequently on sculptures the chiton is only partially visible beneath a HIMATION. A chiton can be either long or short and have either short or long sleeves. Chitons were constructed of two rectangular pieces of fabric sewn along the sides and fastened on the shoulders and upper arms by either seams or buttons: The first evidence of buttons instead of seams is seen on sculptures of the first quarter of the sixth century B.C.

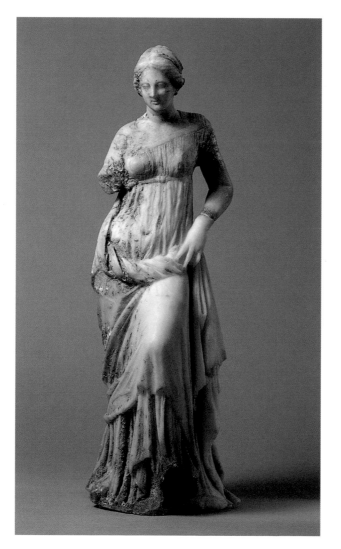

Chiton
Statuette of a Goddess, probably Aphrodite
Greek, about 100 B.C.
Marble
H: 45.1 cm (17¾ in.)
JPGM 96.AA.169
The thin fabric of the chiton is indicated by the depression of this woman's naval, clearly visible beneath the fabric folds. With her left hand she holds the thick twist of her HIMATION wrapped about her hips. Photo: Bruce White.

Chlamys
Grave Stele of
Phanokrates
Greek, about 200 B.C.
Marble
H: 125.4 cm (49⅜ in.)
JPGM 96.AA.50
The chlamys this young
man wears is fastened
on his right shoulder
with an unusual pin in
the shape of a large ivy
leaf. Photo: Bruce White.
(See also illustration for
ANTHEMION, p. 9.)

CHLAMYS

A short cloak worn by Greek men, fastened on one shoulder.

CIPOLLINO MARBLE

A green and white MARBLE (Latin, *carystium*) QUARRIED near Karystos on the island of Euboea in Greece. The pattern of the colors has a banded characteristic somewhat reminiscent of the layers of an onion. This type of marble was very popular during the entire Roman period and was often exported throughout the empire for architectural use, especially for columns.

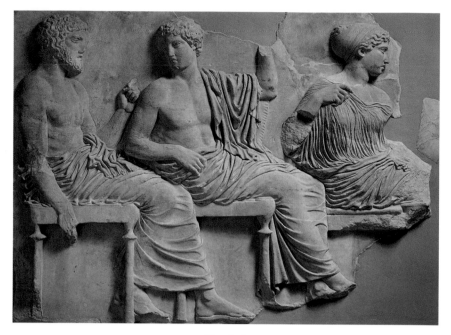

Classical

Poseidon, Apollo, and Artemis on the East Frieze of the Parthenon. Greek (Athenian Acropolis), 445–438 B.C. Pentelic marble. H: 106 cm (41 in.). Athens, Acropolis Museum
The quality and style of the carving used to render the figures on the frieze that wraps around all four sides of the Parthenon epitomizes Classical style. Gods are arranged in conversational groups and depicted as perfectly formed human beings wearing clothing that drapes naturalistically in multiple folds. © Scala/Art Resource, NY.

CLASSICAL

The word used to describe something perceived as being of the highest quality, or "ideal" beauty. Classical often refers to the culture and art objects of Greece in the period from approximately 480 to 323 B.C., but it can also mean the entire Graeco-Roman period. The term Classical also refers to a style of sculpted figures of naturalistic proportions, clear articulation, and quietude. See also CLASSICIZING.

CLASSICAL DRAPERY

Animated poses of the CLASSICAL period demanded a totally new approach to rendering drapery from that used for the static poses of the ARCHAIC period. Following are the four methods, or formal designs, for carving in this new way in order to model a figure in motion.

The **modeling line** was a method of carving the linear pattern of fabric folds; the incised grooves of the folds of the drapery model the forms of the body it covers. The modeling line is especially common in the drapery

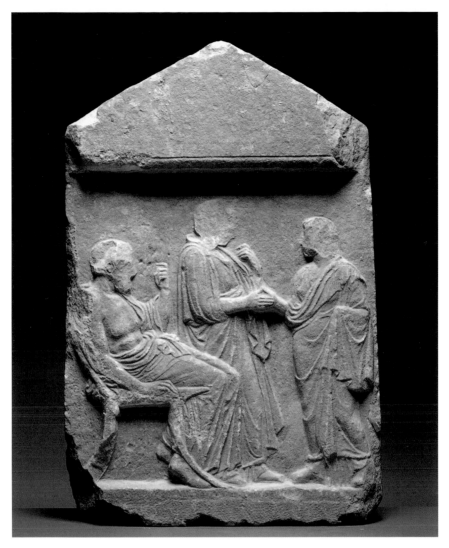

Classical Drapery: Modeling Line
Gravestone. Greek, 425 B.C. Marble, H: 77.5 cm (30½ in.) JPGM 83.AA.206
The pattern of the fabric folds sweeping over the bodies of these three figures is an example of
the modeling line. The grooves of the folds of the cloak wrapped around the hips of the seated man
model the roundness of his hips and suggest the curve of his buttocks.

of the figures from the Parthenon PEDIMENTS (438/7–433/2 B.C.), and it re-
mains important for most of the rest of the fifth century.

A **catenary** is a curve like one made by a flexible cord suspended between
two points on the same level (similar to the curve of a jump rope suspended
from hands held at the same height). In drapery, it refers to a system of

Classical Drapery: Catenary
Fragment of a Funerary Relief of Two Women at a Fountain. Greek, 320–300 B.C.
Limestone. H: 17 cm (6¾ in.). JPGM 96.AA.121
The series of curving drapery folds between these women's breasts, anchored at the nipples,
are examples of catenaries. Photo: Bruce White.

related horizontal curves or looping lines that are formed by the fabric draped over protruding limbs or features. The catenary was used both to stabilize the pose of a figure and to give a unifying pattern to the fabric of the clothing. Catenaries reflect the character of the fabric and help to define the anatomy beneath them.

Illusionary transparency creates an impression of a diaphanous fabric for the clothing of a sculpted figure. It was especially popular among sculptors working in the last thirty years of the fifth century B.C. In order to appear like gathered and transparent fabric, a successful rendering of illusionary transparency depended upon substituting raised ridges for the incised grooves of the modeling line technique (see p. 26) to depict drapery.

Motion lines were added to the drapery of a figure to suggest movement. The vertical ridges and valleys of drapery folds swung backward and outward in long serpentine curves, which often ended in complex hemlines.

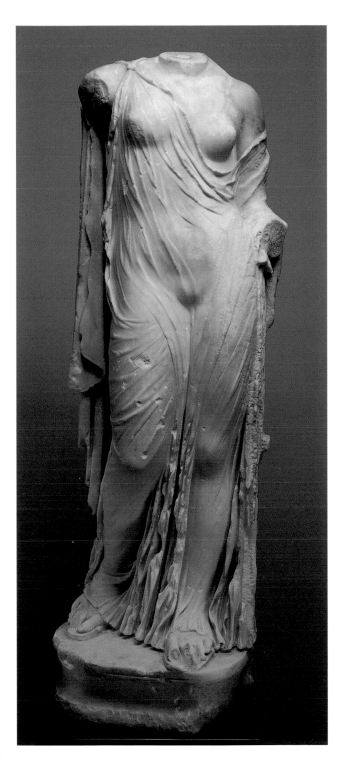

**Classical Drapery:
Illusionary Transparency**
Statue of Venus Genetrix
Roman, second century A.D.
Marble
H: 97.7 cm (38½ in.)
JPGM 96.AA.213
Illusionary transparency is
evident on this Venus: The
pattern of carved ridges
gives the impression of a
diaphanous, transparent
fabric and reveals the
voluptuous forms of her
body. Photo: Bruce White.

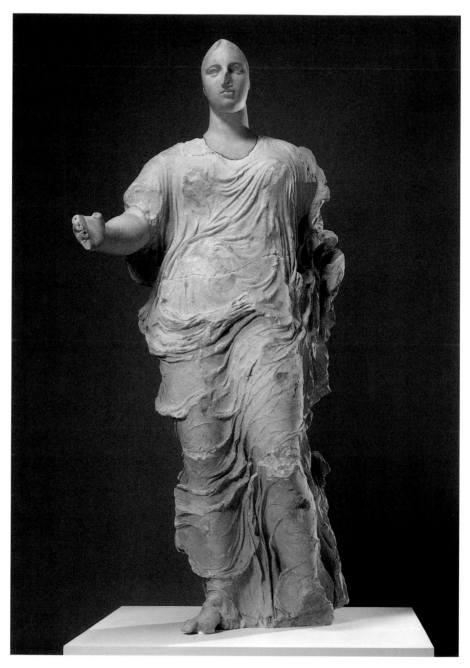

Classical Drapery: Motion Line
Statue of a Goddess. Greek, 425–400 B.C. Marble and limestone with polychromy.
H: 220 cm (86⅝ in.). JPGM 88.AA.76
The way the fabric presses against the legs of the goddess and sweeps back in broad, arching folds
suggests that she stands against a breeze. The motion lines in the drapery give the impression
of the movement of the cloth.

CLASSICIZING

Art of any period that attempts to recreate features of Graeco-Roman art, architecture, and literature. Classicized art is often characterized by a sense of balance, regular proportion, and "ideal" beauty. See also CLASSICAL.

CLAW CHISEL (or TOOTHED CHISEL)

A toothed TOOL used for the removal of the outer layers of the stone. Made from iron or a copper-based alloy in antiquity, it can vary considerably in size and number of teeth (although the minimum is four). Egyptian masons appear to have used it for finishing architectural LIMESTONE blocks as early as the middle of the seventh century B.C.; Greek sculptors began to use this chisel about 560–550 B.C., judging from traces found on datable stone monuments. The great advantage of the claw chisel is that it is easy to control and bites quickly into the stone without damaging the surface. It can be used for modeling, surfacing, and fine finishing, depending upon the angle at which it is held relative to the plane of the stone: to model, it is held almost perpendicular to the surface and hit forcefully with the MALLET, which quickly removes layers of the stone; to produce finer detail or a finished surface, the tool is held at progressively lower angles. A study of Roman TOOL MARKS suggests that the Romans had a wide range of claw chisels but used the tool primarily as a finishing tool. See also TOOLS.

Claw Chisel
Grave Stele of Myttion
(detail)
Greek, about 400 B.C.
Marble
JPGM 78.AA.57
A photograph taken
under RAKING LIGHT of
the corner of this grave
marker shows quite
clearly the marks of the
claw chisel. (See also
illustration for KANDYS,
p. 60.)

CLEANING

Cleaning the surface of a sculpture ranges from simple removal of surface dirt to replacing surface coatings. There are various factors to consider prior to cleaning, such as aesthetics, potential loss of historical information, and the ability to control the cleaning process adequately. What survives on the surface of a STATUE is complex, and much information is contained in alteration or WEATHERING LAYERS and deposits. Inappropriate cleaning can destroy information inherent in traces of PIGMENT and coatings. Even the removal of grime may result in the loss of evidence left from antiquity or from a later period—all of which is part of the history of a particular object.

In antiquity, the application of lye followed by POLISHING was reportedly used for washing statues. Traditional cleaning methods in the post-antique period included mechanical removal with TOOLS such as scalpels or the use of organic solvents or alkali-based aqueous solutions. Recent collaboration by conservators and scientists has produced new and more efficient techniques for cleaning sculptures, including the use of microscopes and lasers, new solvents, soaps, enzymes, poultices, pastes, and gels. See also CONSERVATION, GELS CLEANING.

CLIPEUS

Latin for "round shield." During the HELLENISTIC and Roman periods PORTRAIT BUSTS of rulers and notable figures from the past, such as Greek philosophers, were carved as projecting from a circular shield or medallion. This form of portrait is variously called a clipeus, shield, or medallion portrait.

COMPASS

A TOOL used from an early period to draw or incise perfect circles on sculptures. Small indentations can often be seen at the center of such circles marking the pivot point of the instrument. The compass outlined nipples, rims of the irises of eyes, and fabric patterns.

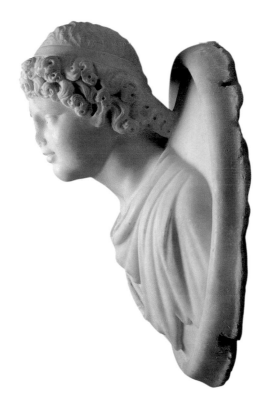

Clipeus
Medallion Portrait
of Caracalla
Roman,
A.D. 198–200
Marble
Diam: 55 cm
(21⅝ in.)
JPGM 73.AA.113
The BUST of the young
Caracalla, who became
emperor in A.D. 211,
projects from a clipeus.

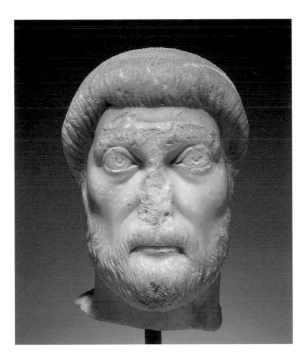

Compass
Portrait Head
of a Man
Roman, about
A.D. 450
Marble
H: 28.5 cm (11¼ in.)
JPGM 83.AA.45
The rim of the irises
of the eyes of this man
were drawn with a
compass.

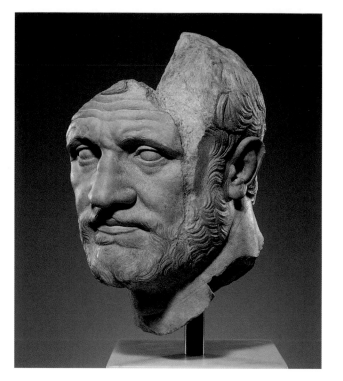

CONSERVATION

All the actions directed toward preserving cultural property for the future are included in the meaning of conservation. A conservator, or conservation professional, is an individual whose primary occupation is the preservation of cultural property in accordance with the Code of Ethics and Guidelines for Practice established for the country in which the individual works. Modern conservation may include RESTORATION (or the replacement of missing parts), but it places emphasis on the retention of original material, reversible treatments, and on the prevention of deterioration and loss. Conservators study, record, retain, and restore an object with as little intrusion as possible to that object. Only materials and techniques that will not cause further damage to the work of art are used; materials that can be easily removed are utilized as much as is practically possible.

Conservation contributes to the history of art through technical studies of the objects, materials, manufacturing processes, processes of alteration, and the accumulation of subsequent surface coatings or grime. Conservation also involves the creation and maintenance of stable environments for objects so that further damage is prevented.

Context

Most Greek and Roman sculpture was made for a specific purpose or function and for a particular location: Function and location could include a cult STATUE in a temple, a VOTIVE OBJECT in a sanctuary, a funerary monument in a cemetery, etc. Unfortunately, most sculptures were portable and thus many, even when found in archaeological excavations, are often removed from their original placements, or are out of context. Some buildings, such as bath complexes and theaters, had a program of sculptural decoration; in this case, when a sufficient number of statues are found during excavation, their original placements—or context—can be reconstructed.

Contrapposto

The pose of the human figure that is described as the perfect compromise between implied motion and stasis. The figure is sculpted in a naturalistic, relaxed stance in which the weight of the body rests on one leg and the opposite arm is bent. This off-center stance (cf. KOUROS) creates anatomical responses in other parts of the body: With the body's weight on one leg, the torso curves away from, or is in opposition to, the lower body. The composition produces a sinuous and regular—but seemingly natural—curve flowing up through the body, which is usually resolved and balanced by the turn and slight inclination of the head toward the weight-bearing leg. This pose was a revolutionary breakthrough in rendering the body, and led to more naturalistic representation. (See also illustration for CANON, p. 21.)

Contrapposto
Votive Relief (detail).
Greek, 150–100 B.C.
Marble.
JPGM 96.AA.167
The nude youth on this RELIEF stands relaxed with his weight on the right foot. His right hip juts out in an exaggerated manner to emphasize the contrapposto of the pose. Photo: Bruce White.

COPY

Any reproduction or facsimile of an original work of art, done in the same form, although not necessarily at the same scale or of the same materials (cf. REPLICA). Certain STATUES and PORTRAITS in antiquity were so renowned and prized that individuals—as well as civic, athletic, and religious groups— desired copies or versions of them. The tradition of copying became an integral part of the activity of sculpture WORKSHOPS. In order to copy a statue in marble, multiple dimensions, by means of precise measurements of many points on the original, must be transferred from the original sculpture to the uncarved block of stone to be carved for the copy. While it appears that Roman sculptors based certain sculptures on Greek originals, they did not seem to have copied them precisely. See also MODEL.

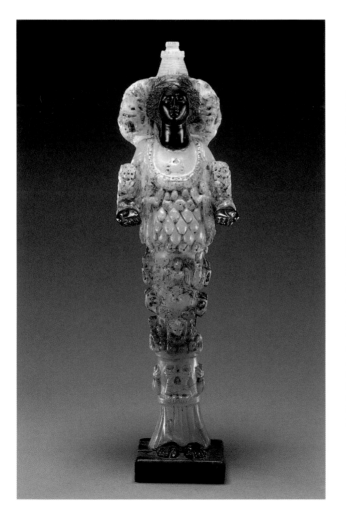

Copy
Statuette of Diana
of Ephesus
Roman,
second century A.D.
Alabaster
H: 30.8 cm (12⅛ in.)
JPGM 81.AA.134
Few STATUES in antiquity
were as distinctive as the
cult STATUE of the
goddess Artemis (called
Diana by the Romans)
located in her temple
at Ephesus in modern
Turkey. The goddess
is covered with an
assortment of animals
and objects that
symbolize her association
with fertility and her role
as mistress of the beasts.
Although the original
statue of the ARCHAIC
period did not survive,
numerous copies exist,
such as this Roman
STATUETTE.

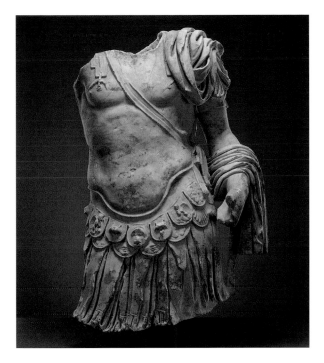

Cuirassed Statue
Torso of a Cuirassed Statue
Roman, about A.D. 83–85
Marble
H: 107.5 cm (42⅜ in.)
JPGM 71.AA.436
This STATUE was originally
carved as a complete figure
to honor a victorious
military leader, whose
PORTRAIT head INSERTED
into the neck cavity would
have identified him.
Symbols on the lappets of
the cuirass date the statue
to the reign of Domitian
(A.D. 81–96). Since the
breastplate itself is
unadorned, the statue
probably commemorates
one of Domitian's generals
rather than the emperor
himself.

CUIRASSED STATUE

This type of STATUE depicts a man wearing full military parade armor; the
cuirass was the armor that covered the body from the neck to the waist. First
seen in the ARCHAIC period to represent soldiers, the statue type became a
popular way to honor Roman emperors and generals. On most cuirassed
statues of the Roman period, the breastplate is carved very elaborately with
symbolic and allegorical RELIEF decoration—often relating to the particular
emperor's reign and emphasizing his power. Such decorative detail often
proves useful for dating and identification when the PORTRAIT head is lost or
otherwise unknown.

CURVED (or BULL-NOSED) CHISEL

This TOOL is similar to the FLAT CHISEL in that the cutting edge is flat in
section, but rounded rather than squared at the end, which helps to prevent
breaking delicate corners and fine details on the stone. It can be used as an
intermediary modeling tool or as a finishing tool. During the first to the
fourth century A.D. marble sculptors in Rome frequently used it as a finish-
ing tool. The marks of this tool often create a light hatching of curved marks,
one following the other along the tool's line of passage.

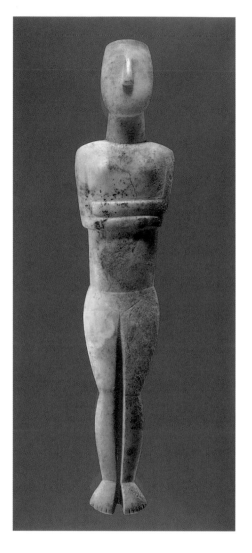

Cycladic
Female Figure
Cycladic, 2500–
2400 B.C.
Marble
H: 59.9 cm (23 ⅝ in.)
JPGM 88.AA.80
With arms folded
across the abdomen,
this figure is typical of
Cycladic sculpture of
the mid-2000s B.C. The
cleft between the legs is
deeply INCISED, but not
cut through.

CYCLADIC

The name given to the earliest known Greek marble sculpture, created from approximately 3200 to 1550 B.C. on the Cycladic Islands in the Aegean Sea. Before bronze or iron technology appeared in this area, beach pebbles and boulders—already partially modeled by the movement of the waves—were often used for figures and vessels. EMERY and OBSIDIAN were used to make INCISIONS, sand and PUMICE to smooth the surface of the sculpted object. After bronze TOOLS were introduced, between approximately 2700 and 2100 B.C., it became possible not only to carve these natural stones in greater detail but also to break off larger lumps of stone from deposits in the earth.

DAEDALIC

A sculptural style of the Early ARCHAIC period (700–600 B.C.); typical features include triangular faces with low, straight foreheads, balanced on either side by masses of hair with strong horizontal waves. There is little depth to the figures; the bodies are usually planklike, the faces masklike. The emphasis is on the overly large head, often with expressive facial features. Figures produced in this period usually wear tubular dresses without pleats (perhaps meant to suggest wool) and pinned at the shoulders. Daedalic figures appear to have been produced primarily at Corinth and Sparta and on Rhodes and Crete. However, the STATUES have been discovered at pan-Hellenic sanctuaries, which were growing in size and importance in the seventh century (e.g., at the sanctuaries of Zeus at Olympia, of Hera at Argos and Perachora, and of Apollo at Delphi and Delos). The name comes from Daidalos, the legendary Greek craftsman, inventor, and sculptor from Athens, who was believed by the Greeks to have made the first human image (Diodorus Siculus *The Library of History* 4.76–79).

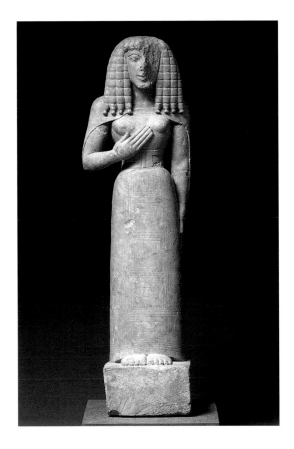

Daedalic
Statue of a Kore
(Lady of Auxerre)
Greek (Crete),
650–625 B.C.
Limestone
H: 65 cm (25 ⅝ in.)
Paris, Musée du Louvre
Ma 3098
The triangular shape of the face and the parallel ranks of hair falling onto the shoulders are typical features of the Daedalic style. Photo: Hervé Lewandowski.
© RMN/Art Resource, NY.

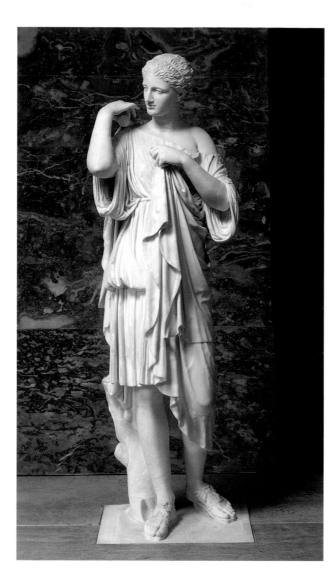

DIPLAX

A HIMATION of medium length folded twice and fastened on one shoulder. The diplax is primarily an item of female dress, seen most often on figures of Athena, Artemis (Diana), Kore, Leto, and on mortal women in festival dress, such as maenads, brides, and bridesmaids. The diplax was, however, worn by Apollo and Dionysos (Bacchus)—both gods with a strongly feminine side. It was especially popular from about 470 to 400 B.C., but is still seen, although far less, on figures of the fourth century B.C., as well as on ARCHAISTIC figures of the HELLENISTIC and Roman periods.

DOLOMITIC MARBLE

A very hard pure-white MARBLE with large crystals and moderately tight grain, QUARRIED in antiquity at Cape Vathy on Thasos, and thus one of the two types of THASIAN MARBLE. Composed of calcium magnesium carbonate, it differs from the other white marbles composed of calcium carbonate. It is virtually without black or colored spots; however, it sometimes contains inclusions and more porous areas that can make a block unusable. Although it POLISHES well, dolomitic marble is difficult to carve in fine detail; sculptors of this stone tended to avoid detail and developed ABRASIVE techniques to achieve such features as eyelids. It was used for sculpture in Thasos, Macedonia, and Thrace from the ARCHAIC to the Late Roman periods; during the latter it was often used in Athens. The second century A.D. seems to have been the main period of diffusion, with export to Italy continuing into the fifth century A.D.

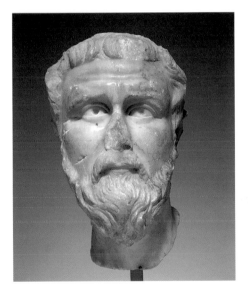

Drill
Portrait of a Bearded Man, a Priest or Saint
Roman, fifth century A.D.
Marble
H: 28.3 cm (11⅛ in.)
JPGM 85.AA.113
The pupils and remaining nostril on this PORTRAIT were formed with a wide-diameter drill. The deeply drilled eyes create a penetrating gaze. The head was carved as an independent element for INSERTION into a separately sculpted body.

DRILL

In Greece the drill was probably a form of the CURVED CHISEL rotated by a handheld bow or strap. Its main purpose was to create holes, but it was also used to shape a channel or a recess in a stone CARVING. The usual technique to create a channel was to drill a line of holes that permitted the stone to be easily cut away with a POINT or CLAW CHISEL. The drill was used at all stages of stone sculpting, from removing blocks in the QUARRY to the final details of a figure, such as hair strands, nostrils, eyes, and ears. See also RUNNING DRILL, TOOLS, UNDERCUTTING.

Drove

A chisel over 3 cm (1 ⅛ in.) wide with a flat, even head that was commonly used to finish flat surfaces; it produced parallel strokes on the stone. The drove was used primarily during the ARCHAIC period in Greece; marks of the drove have not been found on sculptures of the CLASSICAL and later periods. It seems to have been replaced after about 500 B.C. by narrower FLAT and CLAW CHISELS to create more deeply modeled forms. See also TOOLS.

Early Classical

A sculptural style of approximately 480 to 450 B.C. characterized by the more naturalistic rendering of the figure than can be seen on previous ARCHAIC STATUES. Space, movement, and human anatomy were represented with greater freedom. Figures appear more relaxed, avoiding the foursquare rigidity of most Archaic figures. Facial features became more expressive and drapery folds tended to be in a regularly spaced linear pattern of thick, heavy fabric. Most sculptures in the Early Classical style have an austere appearance, hence the style is known also as the Severe or Bold Style. See also CLASSICAL.

Electron spin resonance spectroscopy (ESR)

Electron spin resonance involves the flipping back and forth between the two spinning directions of electrons of an atom in a magnetic field when electromagnetic radiation of a certain frequency is applied. This method of geological analysis can determine the PROVENANCE of marble. Preliminary work suggests that some QUARRIES can be distinguished through ESR of manganese (Mn^{2+}) and iron (Fe^{3+}), but further work in establishing inter- and intraquarry variation is needed. The accumulation of databases for ESR promises to make this method more useful in the future.

Emery

A natural black corundum, or aluminum oxide, emery is the hardest existing substance after diamonds. Greek sculptors found emery on the Cycladic island of Naxos. It was in use already during the Early BRONZE AGE as an ABRASIVE for POLISHING and creating details on both figures and vessels.

Encaustic

A method used to paint stone sculptures. PIGMENTS were mixed in a hot WAX solution and then applied to a roughened prepared surface.

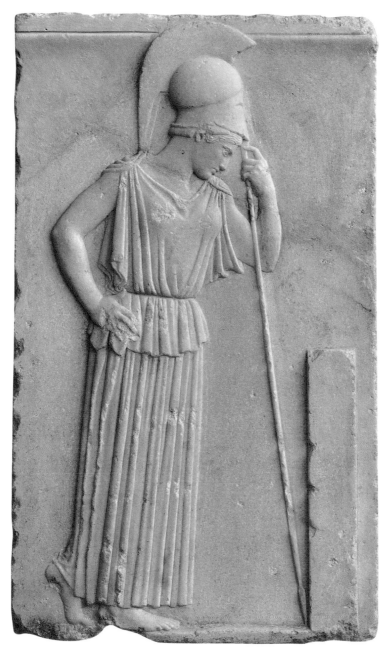

Early Classical

Votive Relief of Athena. Greek, 470–450 B.C. Marble. H: 54 cm (21 in.). Athens, Acropolis Museum
Although CARVING in shallow RELIEF, the Early Classical sculptor has managed to create
an impression of depth and three-dimensionality in this figure of the goddess Athena. The slightly turned
three-quarter pose, the foreshortened perspective of the left arm holding the spear, and the regularly
spaced vertical folds of the thick fabric of the PEPLOS are all features of Early Classical style.
© Scala/Art Resource, NY.

Ensemble

Statues of Four Muses. Roman, about A.D. 200. Marble. H: 91.5–97.4 cm (36–38⅜ in.).
JPGM 68.AA.21, 68.AA.22, 71.AA.461, 94.AA.22 (clockwise from top left)
These four STATUES were carved as an ensemble of muses and other mythological figures, which were
installed in a shrine for an imperial cult of the Antonine and Severan dynasties at Cremna in Pisidia
(southwestern Turkey).

ENSEMBLE

Two or more figures conceived of and sculpted as belonging together. Sculptural ensembles often depicted either a historical or mythological narrative.

EQUESTRIAN

The sculpted figure of a rider upon a horse was a popular image from early on in Greece to the end of the Roman period. In the ancient world horses were objects of status, symbolic of wealth and social standing; honorific STATUES, therefore, tended to be equestrian or chariot groups. While bronze was a favorite medium for equestrian figures, many were also sculpted in marble. Statues of riders on horses became a popular means of portraying rulers—from Alexander the Great, at the beginning of the HELLENISTIC period, to Roman emperors.

Equestrian
Statue of a Horse and Rider (Rampin Rider) Greek (Athenian Acropolis), about 550 B.C. Marble H: 81.5 cm (32⅛ in.) Paris, Musée du Louvre 3104 A slim bearded man rides bareback astride a horse in this equestrian STATUE, one of a pair from the Athenian Acropolis. Many equestrian statues were dedicated on the Athenian Acropolis in the ARCHAIC period, a reflection of the importance of the horse as a symbol of Athenian aristocracy. Photo: Hervé Lewandowski. © RMN/Art Resource, NY.

FILE

This scraping TOOL is flat, rounded, or half-round in form. Files were generally used on flat surfaces or those with large, gradual curves, but this abrasive tool was also used to produce a sharp, clean angle between two planes.

Flat Chisel
Portrait Head of a
Bearded Man, a Priest
or Saint
Roman, fifth century A.D.
Marble
H: 28.3 cm (11⅛ in.)
JPGM 85.AA.113
On the back of the
cranium of this PORTRAIT,
marks of the flat chisel
can be seen on the right
and of the SCRAPER on the
left. (Cf. illustration for
DRILL, p. 41.)

FLAT CHISEL

A TOOL of various widths with a straight cutting edge used for smoothing the surface of stone; it creates flat surfaces and smoothly finished forms. Details and lines can be cut with the corner of the flat chisel, leaving a slightly cut V-shaped channel. The Greeks used the flat chisel after POINT and CLAW CHISEL work as an intermediary tool and to level a surface in preparation for smoothing by ABRASIVES. The Romans used it primarily to smooth and create a uniform surface.

FOURIER TRANSFORM INFRARED SPECTROMETRY (FTIR)

An analytical technique that identifies organic materials present in the ADHESIVES and BINDERS used in POLYCHROMY and GILDING of stone sculpture.

The analysis is possible with only a small sample of any residues of paint or gilding that might remain on a sculpture. As infrared radiation is passed through the sample, some of the radiation is absorbed and some is transmitted. The resulting spectrum (representing the absorption and transmission) creates a molecular "fingerprint" of the sample.

FREESTANDING

A sculpture carved IN-THE-ROUND that stands on its own.

FRONTAL

A sculpture is described as frontal when it has a definite orientation toward the prospective viewer—the front of the STATUE is the intended view. Its visual impact is the result of this frontal presentation. The backs of such statues are often not completely carved. Cf. IN-THE-ROUND.

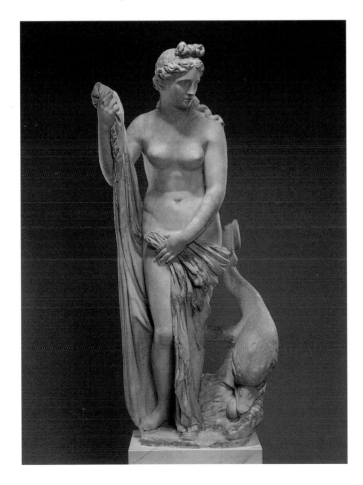

Frontal
Statue of Venus
(Mazarin Venus)
Roman, second
century A.D.
Marble
H: 184 cm (72⅛ in.)
JPGM 54.AA.11
Although this figure is carved IN-THE-ROUND, all the interest in the composition centers on the front of the figure.

GANOSIS

Vitruvius (*De Architectura* 7.9.3–4) and Pliny (*Natural History* 33.122) tell of a WAXING and oiling process called ganosis that was devised by the Greeks to prevent the flaking and fading of STATUES' paint from solar damage. It has been established by scholars that the Parthenon and other marble temples were treated with an organic wash, possibly a part of the process of ganosis.

GELS CLEANING

Used on stone and other media, this CLEANING method uses an aqueous gel base composed of a polymer resin, which thickens with the addition of water, and a surfactant (also a thickening agent) that improves the gel's contact with the surface of the object to be cleaned.

GEOMETRIC

The period in Greek art from approximately 900 to 700 B.C., named after the geometric designs that formed the basis of ceramic decoration. Geometric sculpture takes the form of small solid-cast bronzes and terracotta STATUETTES of simple design. Both animal and human representations were created using basic geometric forms. Stone was not used for sculpture during this period.

GIALLO ANTICO MARBLE

A fine-grained compact MARBLE ranging in color from ivory to dark yellow to golden or saffron colored, often with pink or red veining and, at times, speckling and mottling of these colors. Giallo antico (Latin, *numidicum*) was QUARRIED from the hills that surround Simitthus (modern Chemtou) in Tunisia. It was used in Rome beginning in the second century B.C. for both architecture and sculpture.

GILDING

STATUES could be gilded or silvered. The technique was used most often on bronze statuary, but figures of wood, terracotta, stone, and silver were also gilded (Pausanias *Description of Greece* 10.14.4; 18.7). The Greeks used the process of gilding from the fifth century B.C. onward, but until the late fourth century only on images of the gods; after that the use of gilding was extended to other statue types.

GORGONEION

The severed head of the monstrous Gorgon Medusa. Its representation was believed to ward off evil and provide protection for the wearer.

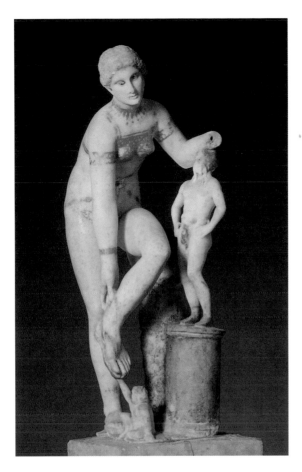

Gilding
Statuette of Venus
Roman,
first century A.D.
Marble with polychromy
and gilding
H: 62 cm (24 ⅜ in.)
Naples, Museo
Archeologico Nazionale,
from House II, 4, 6,
Pompeii
The sumptuous gilding
that was applied to this
marble STATUE of Venus
is still largely intact. The
gilding simulates the
goddess's jewelry and
other ornamentation.
© Scala/Art Resource, NY.

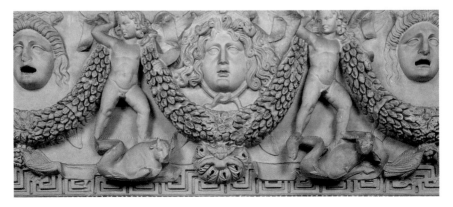

Gorgoneion
Front of a Sarcophagus (detail). Roman, A.D. 200. Marble. JPGM 72.AA.152
In the center of the middle garland on the front of this SARCOPHAGUS is a Gorgoneion. The Gorgon's
head presumably acted to protect the deceased entombed in this stone coffin.

GRID

With the invention of the KOUROS type of STATUE in Greece in the mid-seventh century B.C., sculptors adopted the Egyptian practice of drawing a grid on the block of stone to determine the figure's proportions. Rarely, however, did Greek sculptors adhere strictly to the Egyptian proportional system, revised late in the Twenty-fifth Dynasty (736–656 B.C.), which demanded twenty-one squares from feet to eyes, a quarter cubit from eyes to crown, and intervening features inserted at specified points.

HELLENISTIC

This period is named after Hellas, or Greece, and spans the time from the death of the Macedonian king Alexander the Great (323 B.C.) until the death of Cleopatra of Egypt (30 B.C.). It was a period of expansion for Greek culture and language in the Near East and North Africa. Greek centers of art, science, and literature arose at Pergamon in Asia Minor, Antioch in Syria, and Alexandria in Egypt. Art of this period is often characterized by figures in complex poses of exaggerated motion, exhibiting their psychological and emotional states. See also TORSION.

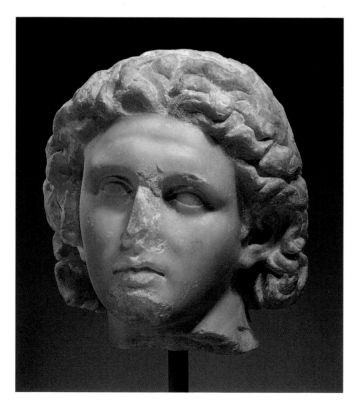

Hellenistic
Portrait Head of Alexander the Great
Greek, about 320 B.C.
Marble
H: 29.1 cm (11½ in.)
JPGM 73.AA.27
Features of this PORTRAIT of Alexander, such as the upswept hairstyle and the deep-set eyes, were adopted by subsequent dynasts. This style and type of image was popular for depictions of the rulers of Hellenistic dynastic kingdoms. Photo: Anthony Peres.

HERAKLES KNOT

This square knot, a symbol to ward off evil, was important in many cultures, including Egypt, where its history as an amulet goes back to the beginning of the second millennium B.C. It was known as a Herakles knot because of the mythic way Herakles wore the hide of the Nemean lion: after killing and skinning the beast, he tied its front paws in a square knot under his chin. The knot became very popular in Greece at the beginning of the HELLENISTIC period, where it was an ornamental or design element in jewelry and costume and was believed to provide the wearer protection because of its magical properties.

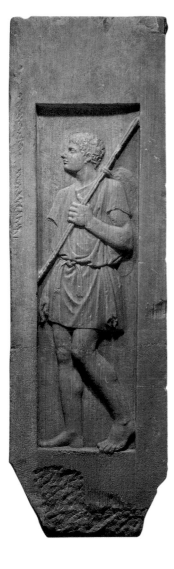

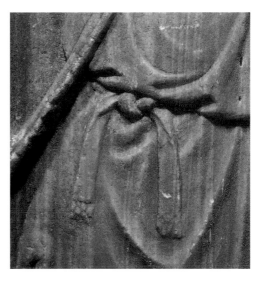

Herakles Knot
Side Relief Panel from
a Grave Monument
Greek, about 300 B.C.
Marble
JPGM 96.AA.48
The belt of this young
man's TUNIC is tied with
a square, or Herakles,
knot. Drawing by Toby
Schreiber.

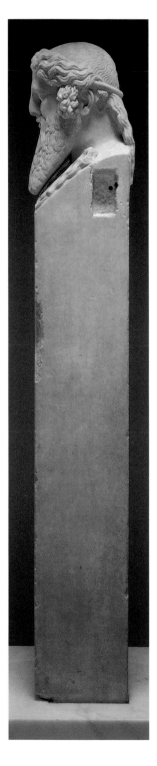

HERM

A STATUE made in the form of a pillar, originally with a phallus and the bearded head of the god Hermes. First made as crossroad and doorway markers, herms were identified with this god, who protected travelers. Sites of ritual and worship, the herms served a magical, protective function. By the HELLENISTIC period the repertoire of heads found on herms had expanded to include other gods, such as Dionysos, and PORTRAITS of historical figures; by the Roman period the form was used for portraits in general.

HIMATION

The himation, commonly worn over the CHITON, was a cloak consisting of a large rectangular piece of heavy fabric, probably wool, usually worn draped diagonally over one shoulder and wrapped around the body. It was an outer garment worn by both men and women. See also DIPLAX.

Herm
Herm of Hermes
Roman, A.D. 50–100
Marble
H: 149 cm (58⅝ in.)
JPGM 79.AA.132
The top of the shaft of this herm is carved in the shape of a head of Hermes. This profile view of the herm shows the cutting for the attachment of one of the bosses (rudimentary arms), which would have supported wreaths and other offerings to Hermes.

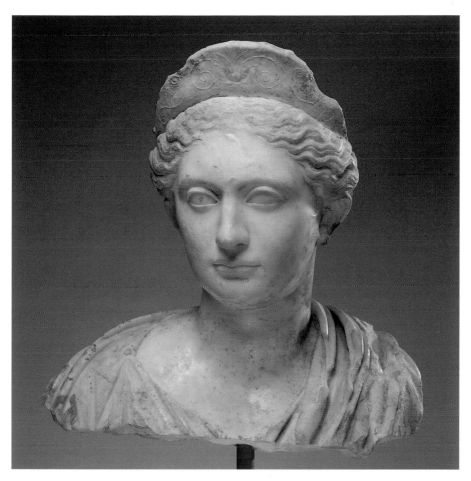

Idealistic

Portrait Bust of Sabina. Roman, about A.D 140. Marble. H: 43 cm (16⅞ in.). JPGM 70.AA.100
Although Sabina, wife of the Roman emperor Hadrian, was probably about sixty years old when
this BUST was carved, she does not look her age. The PORTRAIT, with its youthful idealized features
and emotionless expression, is carved in the CLASSICAL style of fifth century Athens, a style
favored by Hadrian. Photo: Jack Ross.

IDEALISTIC

Sculptures could express either an idealized image of the sitter or one more
naturalistic or true to life. In CLASSICAL Greece carved PORTRAITS represented
a generalized ideal of beauty at the expense of individual characteristics. Ro-
man portraits, on the other hand, typically stressed the individual features of
a person, emphasizing certain character traits or indications of status. See
also VERISTIC.

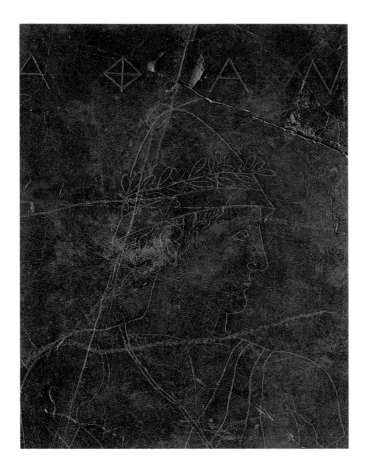

Incision
Grave Stele of Athanias (detail)
Greek, about 400 B.C.
Black limestone
JPGM 93.AA.47
The incised lines that now form the image on this STELE were not meant to be seen; they were the guidelines for the original painted decoration that is now completely gone.
Photo: Jack Ross.

INCISION

Lines lightly carved or punched into the surface of stone to delineate details of anatomy or design, to guide painted patterns, or to cut letters for an inscription.

INFRARED PHOTOGRAPHY

A technique used to discover traces and remains of paint or drawing on stone sculptures that are not necessarily visible to the naked eye. Infrared radiation is absorbed by any dark or carbon-containing PIGMENT that is present on stone. If an object containing any pigment is illuminated with a high infrared source, an image of that pigment can be captured on infrared film or digitally with special electronic cameras.

INLAYS

Drapery patterns, decorative designs, and eyes were sometimes applied to STATUES; glass paste and contrasting colored stones were set into channels (inlaid) cut into the stone.

INSCRIPTION

Greek and Roman sculptures were sometimes INCISED with the name of the person or divinity depicted, the sculptor's name on the BASE, the name of the dedicator (the individual who paid for the STATUE), or the divinity to whom the statue was dedicated. At times an inscription would consist of a short poem or message addressed to the viewer.

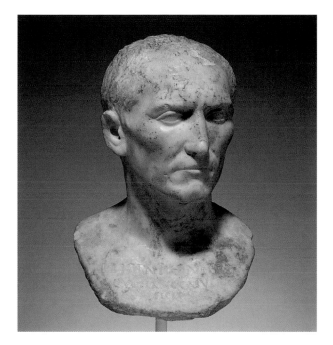

Inscription
Portrait Head of
L. Licinius Nepos
Roman, about
A.D. 100
Marble
H: 37.5 cm (14¾ in.)
JPGM 85.AA.111
The inscription cut into
the stone on the front
of this PORTRAIT BUST
is the name of the
sitter, L. Licinius
Nepos.

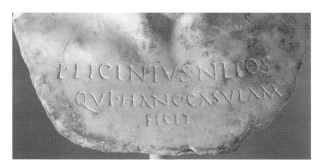

Inscription
Detail of the portrait
head of L. Licinius
Nepos.

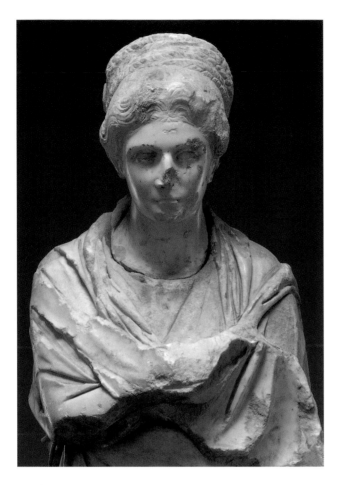

INSERTION

The bottoms of PORTRAIT heads were often carved into conical or tenonlike shapes for placement into a cavity in the top of a sculpted body in order to form a complete STATUE. A client could choose a body type to which his or her likeness would be attached. This practice was especially popular in the Roman period. See also SOCKET AND TENON.

IN-THE-ROUND

A sculpture meant to be viewed from all sides. An in-the-round STATUE is three-dimensional with all parts of it fully carved or modeled. The viewer must walk around the figure to fully appreciate its form. Cf. FRONTAL.

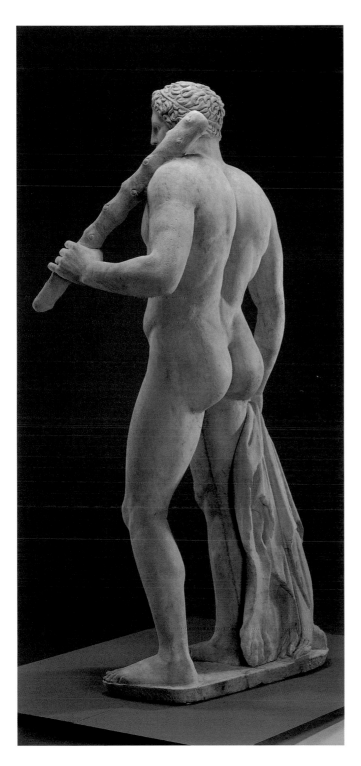

In-the-round
Statue of Hercules
(Lansdowne Herakles)
Roman, about
A.D. 125
Marble
H: 193.5 cm (76⅛ in.)
JPGM 70.AA.109
The hero Hercules is
fully modeled in-the-
round and is meant to
be seen from all sides.

Ionian Workshops
Torso of a Kouros
Greek, about
550–525 B.C.
Marble
H: 51.4 cm (20¼ in.)
JPGM 91.AA.7
The HIMATION over a
long TUNIC worn by
this half-LIFE-SIZE
KOUROS is a typical
type of costume worn
by figures produced
in Ionian workshops.
The youth's rounded
muscular body, and
the smooth carving of
his clinging garment
identify the STATUE
as the product of an
Ionian workshop,
probably located in
the city of Didyma.

IONIAN WORKSHOPS

Centers of sculptural production that were situated in the eastern part of
ancient Greece—the west coast of modern Turkey—and the adjacent islands.
The most prolific of these WORKSHOPS was located on the island of Samos.
Sculptors in Ionian workshops typically produced figures with fleshy bodies
of a uniform roundness, globular heads that frequently appear too large for
the bodies, and broad faces with puffy cheeks and large, somewhat slanted
eyes. There is a distinctive, voluptuous smile from the mid-sixth century on.

IRON AGE

In Greece this period, from approximately 1050 to 900 B.C., is referred to as
the Dark Ages in older literature. The Iron Age followed the collapse of the
MINOAN and MYCENAEAN palatial civilizations of the Late BRONZE AGE and
was marked by a serious decline in culture: There was a virtual disappearance
of monumental architecture, art depicting the human figure, and writing.

Although no large sculpture was produced, small stylized figurines were made. However, technological innovation with the widespread use of iron occurred, hence the name given to the period.

JOIN

The site of the attachment of one part of a STATUE to another part to create a whole figure or composition. Creating joins and PIECING statuary became a necessary sculptural skill for two reasons: Monolithic blocks of stone suitable for carving LIFE-SIZE or larger STATUES were frequently unavailable, and adding limbs or elements that extended away from the body into space was difficult in single-block sculptures. Separate pieces of stone were used for the head or legs. Although a metal dowel, or PIN, might be inserted for added strength and the join sealed with light cement, or ADHESIVE, the most common method of creating a join was with an extremely snug-fitting SOCKET AND TENON; variations of the latter method remained the usual way of joining through the Roman period. Sculptors started piecing work together as early as the sixth century B.C., about the time large FREESTANDING statues were first being carved. The last two centuries B.C. and the first century A.D. were periods of high production of pieced sculptures.

Join
Torso of a Cuirassed
Statue
Roman, about
A.D. 83–85
Marble
H: 107.5 cm (42⅜ in.)
JPGM 71.AA.436
A separately carved
piece was originally
joined to the back
of this STATUE to
complete the figure.
The joining area was
finished flat with a
CLAW CHISEL and the
piece was then joined
to the shoulder by
means of a dowel (or
PIN). The hole for
receiving the dowel
is at the top of the
flat area. (See also
illustration for
CUIRASSED STATUE,
p. 37.)

KANDYS

A coatlike garment of three-quarter length with long sleeves. It originated in Persia and was adopted by Athenian women at the end of the fifth century B.C., a period when increasing imports from Asia Minor influenced fashion.

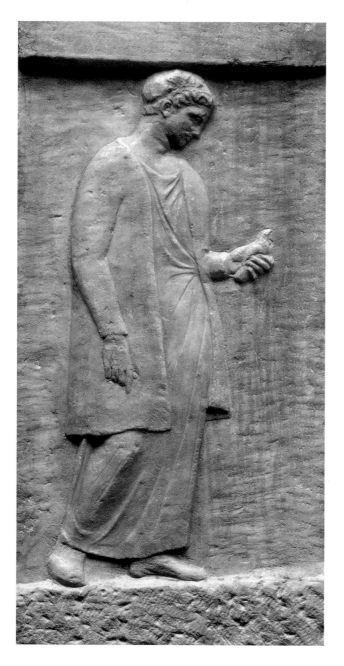

Kandys
Grave Stele of Myttion (detail)
Greek, about 400 B.C.
Marble
JPGM 78.AA.57
The young woman on this grave marker, Myttion, wears a kandys over her long dress.

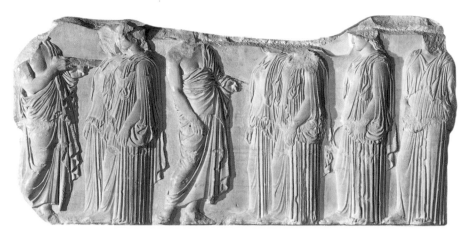

Kanephoros
Kanephoroi on the East Frieze of the Parthenon. Greek (Athenian Acropolis), 445–438 B.C.
Pentelic marble. H: 96 cm (37¾ in.). Paris, Musée du Louvre Ma 738
Pairs of girls wear the festival clothing of kanephoroi on this slab of the frieze, which depicts a sacrificial
procession. Photo: Hervé Lewandowski. © RMN/Art Resource, NY.

KANEPHOROS (pl. KANEPHOROI)

Maidens from noble families of Athens and throughout Attika who were specially chosen to be participants in certain cults. These women wore special clothing and hairstyles signifying their special cultic status and carried baskets that held cult paraphernalia, such as the knife used to kill a sacrificial animal. For festivals they usually wore a PEPLOS, sometimes a CHITON, but always a cloak that was draped over their shoulders so that it hung down at the back. Long hair, indicating that they were unmarried virgins, hung loose at the back.

KOLPOS

The fold of a garment, usually of the CHITON but also seen on the PEPLOS, that falls over a belt; it is a loose pocket of fabric similar to the modern blouson. (See illustration for PEPLOS, p. 76.)

KORE (pl. KORAI)

A Greek word meaning maiden, it is also the term for sculptures of draped female figures of the ARCHAIC period. Korai functioned as VOTIVE offerings, or dedications in sanctuaries and temples, or as funerary STATUES marking the graves of deceased young women. STATUES of korai typically stand erect with one leg slightly advanced, one hand extended with an offering, and the other holding a gather of the dress to the side. Korai are usually clothed in

Kore
Fragment of a Statue
of a Kore
Greek, about 530 B.C.
Parian marble
H: 73 cm (28¼ in.)
JPGM 93.AA.24
Nearly LIFE-SIZE,
this damaged STATUE
represents a kore. She
wears a long CHITON
of sheer fabric with a
cloak over it, which is
fastened diagonally on
one shoulder.

dresses of thin fabric with multiple pleats and folds that are partially covered with cloaks to create a layered effect. Hairstyles, decorative and ornately elaborate, are composed of repetitive patterns of locks, strands, braids, and curls. (See also illustration for ARCHAIC, p. 10.)

KOUROS (pl. KOUROI)

General term for sculptures of the ARCHAIC period that depict a nude young man—the Greek word means youth—standing with his hands at his sides and one foot (usually the left) set somewhat forward. Although the pose recalls Egyptian male STATUES and was almost certainly influenced by them, kouroi differ dramatically: They were carved IN-THE-ROUND, unlike their Egyptian predecessors, which always had a supporting mass of stone attached to the legs. Additionally, Egyptian statues of men were always clothed. The physique of the kouros is athletic and muscular, and to the Greeks a kouros represented the ideal image of fitness and handsomeness for the human being or god that was sculpted.

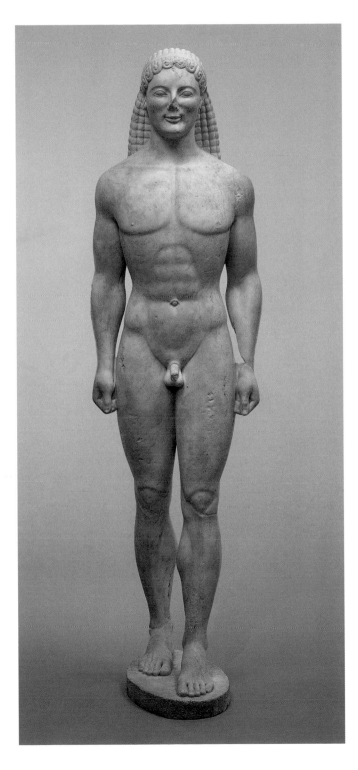

Kouros
Statue of a Kouros
Greek, about 530 B.C.,
or modern forgery
Marble
H: 206 cm (81⅛ in.)
JPGM 85.AA.40
Slightly larger than
LIFE-SIZE, this STATUE
of a young man
exemplifies the kouros
statue type. The nude
youth stands with his
left leg advanced, both
feet firmly planted on
an oval PLINTH, and
his arms at his side. An
enigmatic smile, known
as the "ARCHAIC
smile," crosses his lips.
The authenticity of
this kouros has been
questioned because
the figure consists of a
mixture of earlier and
later stylistic traits.
Additionally, the use of
marble from the island
of Thasos at about
530 B.C. is unexpected.
To date, neither art
historians nor scientists
have been able to
resolve the issue.

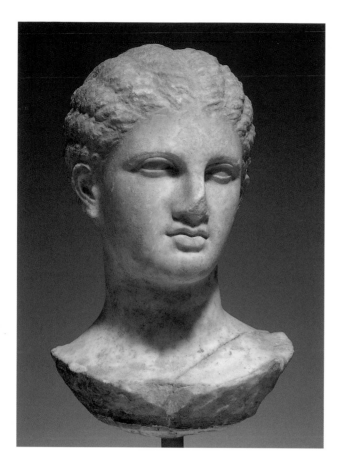

Late Classical
Head of a Woman
Greek, about 320 B.C.
Marble
H: 34.3 cm (13½ in.)
JPGM 56.AA.19
The so-called melon
coiffure worn by this
woman was an
innovation of the Late
Classical period. Also
typical of this period
was the elaboration of
funerary monuments,
which grew into large
architectural structures
that housed multiple
figures. This IDEALISTIC
PORTRAIT head belongs
to a now-missing
funerary STATUE of
this kind.

LATE CLASSICAL

The period from approximately 380 to 323 B.C., a time of transition between the earlier CLASSICAL and the later HELLENISTIC periods. Sculptural styles follow the Classical forms developed in the fifth century B.C., but with innovations such as the introduction of the female nude STATUE, VERISTIC PORTRAITS, emotional expressiveness, and dramatic poses. Changes in clothing include PRESS FOLDS; crinkly, crumpled textures; and high-girt dresses. This period followed the defeat of Athens by Sparta during the Peloponnesian War: Political power and wealth shifted from Athens to northern Greece and Macedonia. The period marks the rise of Philip II of Macedon and Alexander the Great, his son. Sculptors and craftsmen moved from serving wealthy city-states such as Athens to serving wealthy individuals and dynasts, such as the Macedonian court of Philip II.

LEAD

A very heavy, soft metallic element that is bluish in color but tarnishes to a dull gray. Lead is malleable, ductile, easily fused, and may be cast, wrought, or hammered into shapes. It was used to facilitate the JOINING of parts of a stone sculpture or to secure a figure to its BASE: Molten lead was poured into special channels cut into the parts to be joined or between the PLINTH and the base of a STATUE. Because of the malleable quality of lead in joins, it helped PIECED sculptures absorb the shockwaves of earthquakes, thus affording a certain amount of protection to statuary. Lead was durable and waterproof, an advantage when rainwater infiltrated the join of a sculpture out in the open.

LEAF GILDING

A technique of GILDING in which sheets of gold leaf were laid directly onto the surface of a stone sculpture and fixed in place with an organic ADHESIVE, which was probably animal glue (made from skin and bones) or albumin from eggs, milk, or blood. Gold leaf was well known in antiquity, as reported by Pliny (*Natural History* 33.61–62). Leaf gilding was not very durable; exposure to either the weather or soil—if the sculpture was buried—makes organic adhesives biodegrade.

LIFE-SIZE

General term used as a benchmark for the scale of individual sculptures. Life-size—more or less natural size—or less than life-size was the sculptural scale reserved, primarily but not exclusively, for mortals. Life-size was also the scale commonly used for PORTRAITS of historical figures, including those of politicians, philosophers, and intellectuals. Sculptures that were made greater than life-size were usually images of gods, goddesses, and other divine beings, or for portraits of rulers from the HELLENISTIC period on.

LIMESTONE

Consisting mostly of calcium carbonate, limestone is of organic origin, formed from shells and coral sediments of ancient seabeds under great pressure. Limestone is found in hard or soft varieties. The latter can be WORKED with TOOLS similar to those used for carving wood, such as gouges, knives, and SCRAPERS. In general, the softness and lightness of both varieties have two advantages: They are easy to cut and handle, and the surface can be covered with paint. Especially in earlier periods, Greek sculptors utilized local sources of limestone, as was done on both Cyprus and Sicily. In general, however, the material was considered inferior to MARBLE, which was preferred and often imported.

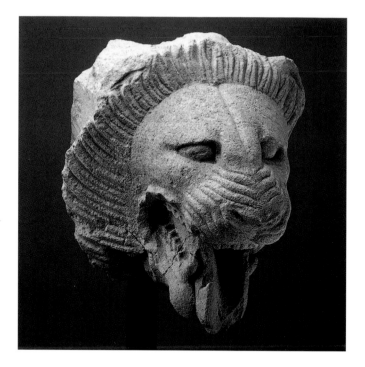

Limestone
Lion's-Head Waterspout
Greek, about 450 B.C.
Limestone
H: 17.5 cm (6 ⅞ in.)
JPGM 96.AA.120
The style and
material of this lion
are consistent with its
origin in one of the
Greek colonies in South
Italy or Sicily. While
these areas had no
native marble source,
good-quality limestone
was plentiful. The size
of the head indicates
that it came from a
small building. Photo:
Bruce White.

LYSIPPOS

Greek sculptor who flourished from approximately 370 to 300 B.C. in Argos (Pliny *Natural History* 34.61–65). Lysippos developed a CANON of proportions for the human figure that differed radically from those of two of his predecessors, POLYKLEITOS (who had also devised laws of proportion) and PRAXITELES (known for his more graceful figures). Bodies carved by Lysippos (and his followers in the SCHOOL of Lysippos) are more slender, with long limbs and small heads, and give the illusion of being taller. Limbs often extend away from the body so that Lysippos's figures occupy more physical space. He also paid great attention to the details of the coiffure.

Lysippos appears to have studied movement and devised methods to impart a sense of motion in his figures: shifts in weight, unsteady poses, arms that change direction, a figure rising from a bent posture—experiments in movement that had not been explored as thoroughly by previous sculptors. There is no single, primary viewpoint to observe a Lysippan STATUE—the viewer must keep moving to appreciate the whole statue, which in itself creates the illusion of movement in the figure. He was especially skilled at sculpting figures with vitality and naturalism. Lysippos claimed that Nature was his model and inspiration, not any previous artist or sculptural tradition.

MAGNA GRAECIA

Latin for "Greater Greece," this was the geographical area of southern Italy colonized by the Greeks. The term is often understood to include Sicily as well.

MALLET

A hammer made of either wood or metal used for striking a CHISEL in sculpting wood or stone. See also TOOLS.

Mallet
Votive Relief
Greek or Roman
Marble
H: 35.6 cm (14 in.)
New York, The
Metropolitan Museum
of Art, Rogers Fund,
1923, 23.160.81
This RELIEF depicting
a mallet and CHISEL,
a dedication in a
religious sanctuary,
was probably given by
a sculptor. Photo: The
Metropolitan Museum
of Art.

MARBLE

A hard, crystalline rock—a form of calcium carbonate—that ranges from fine- to large-grained and is capable of being WORKED and smoothed to a high POLISH. Marble is extremely dense, with an average weight of about 77 kg (170 pounds) per cubic foot. It is a metamorphic form of LIMESTONE, which is similar in chemical composition although not in structure or appearance. The marbles of most known exporting QUARRIES throughout the ancient Mediterranean consist primarily of the mineral calcite (calcium carbonate). Some varieties of marble are metamorphic dolomites, however, and contain magnesium carbonate as well as calcium carbonate.

The general use of marble for Greek sculpture began in the seventh century B.C. and became firmly established during the sixth. Marble is ideally suited for sculpting the human form, a subject that was central to western sculptural production from ancient times through the nineteenth century.

Marble is also an excellent surface for POLYCHROMY, which was applied to all Greek and Roman stone sculpture.

Marble was abundantly available in Greece and the Roman Empire— a important factor in the development and production of sculpture. In the beginning white marbles were used—coarse-grained NAXIAN and fine- to medium-grained PARIAN. Early in the fifth century B.C. Athens developed the quarries of nearby Mt. Pentelikon and from that point on, most Attic sculpture was of this type of marble. Occasionally, the bluish-gray marble of another mountain near Athens, Mt. Hymettos, was used. Glittering THASIAN marble is bright white and hard and occurred in Athens only in works of the Roman period. The quarries of Luna (CARRARA) in Italy were not worked and exploited extensively until the late first century B.C. (Pliny *Natural History* 36.14, 48), although the Etruscans carved STATUES of Luna marble as early as the third century B.C. Especially during the HELLENISTIC and Roman periods colored marbles were used, such as GIALLO ANTICO, ROSSO ANTICO, NERO ANTICO, and PAVONAZZETTO; their color variations were exploited to create dazzling effects.

Unlike bronze statuary, marble sculptures have survived in fairly large numbers because of their weight and the apparent lack of intrinsic value, features that made them less suitable for transportation or destruction. Many marble sculptures, however, were destroyed in limekilns in the post-antique period to produce lime for whitewash. See also DOLOMITIC MARBLE.

MECHANICAL CLEANING

A method of CLEANING marble and other stones that involves the use of precision hand tools and magnification to remove encrusted dirt or other accretions.

MENISKOS (pl. MENISKOI)

A form of metal ATTACHMENT that has survived as bronze or iron rods extending from the tops of heads of KORAI and other figures sculpted during the ARCHAIC period. Scholars have suggested that the original form of a meniskos was either the simple rod that remains today, or the rod with an added part, such as a disc or crescent, or even an elaborate headdress. Their function may have been to prevent birds from perching on the marble sculptures, as suggested by Aristophanes (*The Birds* 1114–17).

MINOAN

Named after the legendary king Minos, Minoan refers to the civilization cen-
tered on the island of Crete known for the construction of large architectural
complexes of a palatial nature. The civilization has been divided into Early
Minoan (3000–2000 B.C.), Middle Minoan (2000–1580 B.C.), and Late Mi-
noan (1580–1450 B.C.). Some sculpture was produced, primarily STATUETTES
of faience, bronze, ivory, and terracotta; stone was used primarily to carve
vessels of various sizes and shapes.

MODEL

Pliny mentions the use of a model (the representation of a figure or object
used as the pattern for a finished sculpture) in *Natural History* (35.155–56),
where he writes of two sculptors from the first century B.C., Arkesilaos and
Pasiteles. The latter was possibly the first to produce sculpture by COPYING
an exact full-size model. Models for Early DAEDALIC statuary were probably
made of wood; terracotta models were used later.

Model
Sculptor's Model (front and rear views). Greek, first century B.C.
Limestone. H: 7.7 cm (3 in.). JPGM 81.AA.164
Measurements are INCISED in a GRID on the back of this sculpted PORTRAIT of a late Ptolemaic
ruler. This means that the head was a sculptor's model, and the measurements were a means of
transferring the proportions of the model to the actual sculpture during the carving process.
This traditional way of carving from a model was begun by the Egyptians.

MOUNTING

STATUES were generally positioned and secured, or mounted, on their BASES or PEDESTALS with molten LEAD; the PLINTH of a stone statue was fitted into a corresponding depression in a base and affixed with molten lead.

MYCENAEAN

This civilization overlapped and then dominated the MINOAN civilization. Dating from approximately 1600 to 1050 B.C., its name comes from the city of Mycenae in the Peloponnese of mainland Greece, the center of this civilization. Sculptures produced included large-scale RELIEFS as well as STATUETTES of ivory and stone.

NAXIAN MARBLE

The Cycladic island of Naxos has abundant MARBLE, which was used for sculpture as early as the mid-seventh century B.C., but more widely during the sixth century B.C. Some of the QUARRIES were in close proximity to the sea, which made export trade economically feasible. Naxian marble fell out of favor at the end of the sixth century B.C., partly due to its very large crystals, which made carving minute details difficult, and partly because it tended to be gray in color; it was superseded by PARIAN marble. The earliest traces of marble QUARRYING on Naxos appear to have been at the village of Apollonas.

NEO-ATTIC

A term coined in the nineteenth century for a style of sculpture that was first produced by sculptural WORKSHOPS in Athens beginning in the second century B.C. These sculptures were primarily based on the style of CLASSICAL ATTIC sculpture of the fifth and fourth centuries B.C. Neo-Attic sculptures were not exclusively based on Classical sources, however; works were also produced after ARCHAIC and HELLENISTIC MODELS. Neo-Attic sculptures were especially promoted in Rome around the time of Augustus (r. 27 B.C.– A.D. 14), the first Roman emperor.

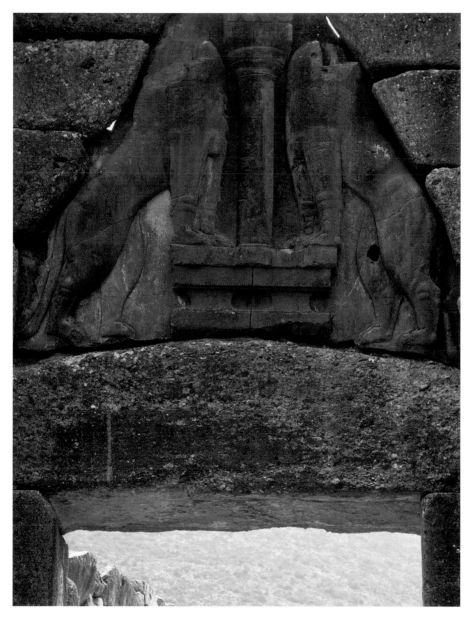

Mycenaean

Lion Gate. Mycenaean, about 1250 B.C. Limestone. Mycenae
This sculpture—the keystone over a massive lintel in a gateway—was carved in a composition of two
lions flanking a column, and was located in the main part of the walls surrounding the city of
Mycenae. Now lost, the heads of the lions were separately carved and attached by JOINING.
Photo: Erich Lessing/Art Resource, NY.

NEOLITHIC

The period in Greece from approximately 6000 to 3000 B.C. Marble carving is known from about 5000 B.C. from small anthropomorphic figures that were carved on the mainland of Greece and on the CYCLADIC Islands.

NERO ANTICO MARBLE

A dark gray to black MARBLE with occasional white spots, lines, or round marine fossils. Aside from color, its main characteristics are an extremely fine grain and uniform density. Although QUARRIED in several locations, each yielded little of the material. It was utilized by both Greek and Roman sculptors, mainly in the first through third centuries A.D. Nero antico was primarily quarried at Cape Tainaron in the Peloponnese of Greece, but Roman imperial QUARRIES have also been identified at Djebel Aziza in Tunisia.

OBSIDIAN

A glassy volcanic stone. Because obsidian fractures into razor-sharp pieces, it was used for carving wood and ivory and possibly to finish the finer details of marble sculptures. Obtained from the island of Melos, obsidian was used for TOOLS in the NEOLITHIC period when there were no metal tools.

ORIENTALIZING

A transitional period (approximately 750–650 B.C.) between the GEOMETRIC and ARCHAIC periods. The influence of eastern civilizations, such as Syria, Egypt, and Phoenicia, can be seen during this period in the art produced by Greek craftsmen. Human and animal figures became more important, and new motifs were adopted, such as battle scenes, fighting animals, and winged hybrid creatures. Perhaps most significantly, the idea of using stone for architecture and sculpture was embraced.

PALLA

Latin for the cloak worn by Roman women, its counterpart is the HIMATION in Greece. When out of doors, Roman women covered their bodies and probably their heads as well with this long rectangular piece of cloth to protect themselves against both the elements and impropriety.

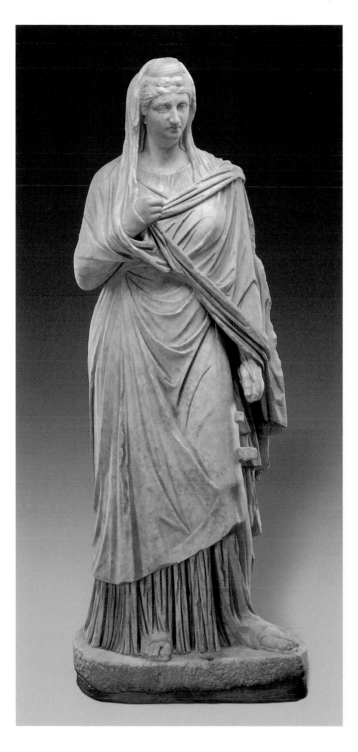

Palla
Statue of Faustina
the Elder
Roman,
A.D. 140–160
Marble
209 cm (82¼ in.)
JPGM 70.AA.113
Faustina, wife of
the Roman emperor
Antoninus Pius
(r. A.D. 137–161), is
a properly dressed
matron with her palla
pulled up over the
back of her head.

PALUDAMENTUM

The Latin name for the short, purple-red mantle of a Roman general, fastened at the left shoulder and worn over armor. (See illustration for CUIRASSED STATUE, p. 37.)

PARIAN MARBLE

MARBLE from the Cycladic Island of Paros. The most famous, Parian Type I, was called *lychnites* in ancient times (Pliny *Natural History* 36.14) because it was worked by lamplight (*lychnos*). It was QUARRIED in two underground shafts and in a series of open QUARRY sites located in the valley of Aghios Minas in the central part of Paros near the village of Marathi. Available to ATTIC sculptors before the CLASSICAL period, it was crystalline and beautifully transparent and became preferred for single STATUES. Parian Type I has a fine-to-medium grain and is warm white and lustrous—a condition caused by light penetrating the stone and reflecting off the surfaces of deeper crystals. The color is generally uniform, without streaks or spots.

There are at least two other types of white marble from ancient quarries on Paros, Parian Types II and III, which are characterized by a slightly larger or medium grain-size, a different isotopic signature, and different trace-element composition than Parian Type I. See also STABLE ISOTOPIC RATIO ANALYSIS, TRACE-ELEMENT ANALYSIS.

PAUSANIAS

Perhaps from Lydia, this Greek traveled in the Roman world during the mid-second century A.D. He wrote the *Description of Greece*, an account of his travels around Greece at a time when the sites of Greece still functioned as sanctuaries but were beginning to be visited by outsiders. His testimony of ancient Greek sculpture is of invaluable significance: Pausanias frequently wrote about STATUES that may have been created up to a millennium before and were more or less intact at the time he saw them. His descriptions are of enormous benefit to all the scholars and art historians who have followed.

PAVONAZZETTO MARBLE

A fine-grained white-to-muted-yellow MARBLE with purplish veins and markings. Pavonazzetto comes from Docimium (in central Phrygia in Asia Minor in antiquity, and thus called Phrygian marble by the Romans). The marble was very expensive in antiquity because the QUARRIES were hundreds of kilometers from navigable transport. The earliest evidence for pavonazzetto in

Rome is from the late first-century-B.C. reconstruction of the Basilica Aemilia by the emperor Augustus after the fire of 13 B.C. Under Augustan patronage or direction pavonazzetto was exploited on a large scale. It was much favored by the emperor Hadrian, and its use became especially popular during his reign (A.D. 117–138). See also AFYON MARBLE.

PEDESTAL (see BASE)

PEDIMENT FIGURES

Early in the sixth century B.C. the low-pitched gables (pediments) that had become common in seventh-century temples began to be decorated with sculpture. These early pediment figures were carved at first in low RELIEF, then higher relief, and, by the EARLY CLASSICAL period, pediment sculptures were carved partly in relief and partly IN-THE-ROUND. Following this the figures were created exclusively in-the-round. They were carved before they were lifted and installed in the pediments; their PLINTHS were fastened to the cornices of the pediments with bronze clamps and LEAD PINS.

PENTELIC MARBLE

White MARBLE that comes from Mt. Pentelikon near Athens, it began to be intensively exploited during the second decade of the fifth century B.C. Although first available to sculptors in the sixth century B.C., Pentelic marble was used extensively for both sculpture and architecture from the fifth century B.C. through the Roman period. The QUARRIES were located from 500 to 1020 m (1640 to 3346 ft.) above sea level, mainly along the south side of Mt. Pentelikon's central massif. Prospecting probably began on two parallel beds of the best marble that were visible on the surface, which then led to the discovery of further beds by means of QUARRYING. Pentelic marble is frequently veined with inclusions of accessory minerals, including quartz, white micas, graphite, sulfides, and iron oxides. After this marble is sculpted, exposure of the iron oxides to the atmosphere gradually turns the marble a warm golden brown. Micaceous layers and inclusions, distinctive characteristics of this marble, are often visible in completed sculptures.

Peplos
Fragment of a Statue
of a Kore (Elgin Kore)
Greek, about 475 B.C.
Marble
H: 71 cm (28 in.)
JPGM 70.AA.114
Even though this STATUE
of a KORE is damaged,
the peplos she wears
is identifiable by the
shoulder fastenings, the
straight linear pattern
of the fabric folds, and
the overfold (KOLPOS)
of fabric above the belt
at the figure's waist.
Above, detail of the right
shoulder fastening of the
Elgin Kore's peplos, seen
from above. Photo:
Anthony Peres.

PEPLOS

A distinctive long garment worn by women, pinned at the shoulders, usually
open on one side, and frequently belted. It was short-sleeved or sleeveless,
symmetrically draped, and worn alone or over a CHITON. The peplos was
made of relatively thick material, probably wool; frequently there were geo-
metric and floral patterns woven into it. A special peplos was woven by maid-
ens in Athens for Athena, the patron goddess of the city, and presented to her
on her birthday during the greater Panathenaic festival held every fourth year.

PETROFABRIC ANALYSIS

An analysis that involves the microscopic study of cross-sections of stone to determine its PROVENANCE. Although petrofabric analysis has been used successfully to distinguish some marbles, the technique is not generally practical for most archaeological artifacts because it requires a large amount of material for analysis. The lack of a sufficient database further limits its usefulness.

PHEIDIAS

The most renowned Greek sculptor in antiquity (Pliny *Natural History* 36. 18–19). An Athenian, Pheidias (approximately 490–430 B.C.) was named Athenian state artist by both Kimon (r. 476–463 B.C.) and Perikles (r. 462–429 B.C.). As such he had a role in designing and supervising the architectural sculpture program on the Parthenon, which was built on the Acropolis between 447 and 432 B.C. Sculptor par excellence, Pheidias was responsible for the colossal gold-and-ivory cult STATUES of Zeus at Olympia and of Athena at Athens (Pliny *Natural History* 34.54), constructed for their respective temples. Not a single original work by Pheidias survives, but some have been reconstructed from descriptions in ancient literary sources and from later COPIES. Pheidias was praised in ancient sources for creating figures of beauty and grandeur—especially those of divinities. In addition, he was renowned for his versatile and inventive use of materials and sculpting techniques and for reportedly being equally skilled in creating figures of marble, bronze, ivory and gold, and for the creation of ACROLITHS.

PICK

A large TOOL used primarily for QUARRYING marble and roughly finishing a block of marble. A pick has a metal head with either points at both ends or one end pointed and the other shaped into a flat blade; the head is attached to a long wooden handle that is held by both hands. It makes distinctive marks in the form of crushed grooves, some of which are still visible on the walls of ancient QUARRIES.

PIECING

The practice of taking small blocks of stone and JOINING them to one another to create a block large enough to carve a given figure. The pieces were joined by carving SOCKETS AND TENONS or by fastening together two smooth surfaces with metal dowels (PINS) or an ADHESIVE. As sculpture became more complex, extensive use was made of piecing: Projecting limbs, segments of drapery, ATTRIBUTES, and sometimes heads were carved separately and

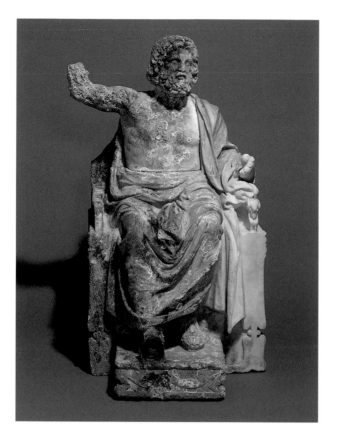

Piecing
Statue of Zeus
Greek, about 100 B.C.
Marble
H: 74 cm (29⅛ in.)
JPGM 92.AA.10
The head and chest of
Zeus were of one piece
of marble that was
JOINED to another
piece to form a block
of marble large enough
to carve this figure.
The join between the
separate pieces is
clearly visible along
the vertical edge of the
HIMATION on the right
and the horizontal fold
at the waist. Photo:
Jack Ross.

attached. Frequently the head and sometimes the hands were separate pieces
that were added to Roman STATUES. (See also illustration for ADHESIVE, p. 5.)

PIGMENT

A dry, pulverized, refined mineral extracted from rocks, sometimes colored
with plant or animal dyes, which when mixed with liquid or a BINDER be-
comes paint. The principal colors used in antiquity were blue and red; yel-
low, green, brown, black, and white were used to a lesser extent. Common
binders included egg, WAX, bitumen, and honey. See also POLYCHROMY.

PIN

Called rods or dowels as well, pins are long, thin pieces of metal used to JOIN
separate parts of a single marble sculpture. While some pins could have been
wooden, most would have been made of metal, especially iron. In the post-
antique period many of these pins were removed from STATUES so the metal
could be REUSED, often for military purposes.

PLINTH

Functioning more or less as a floor for the sculpture, the plinth is the slablike, flat structure or support immediately beneath a STATUE. Normally the edge of the plinth was finished smoothly enough to be inserted and fastened into a depression on the top of a BASE.

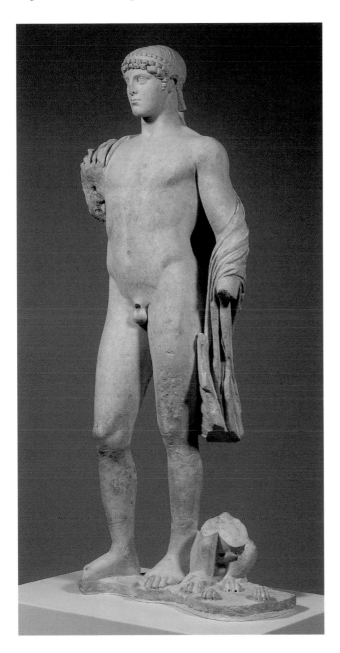

Plinth
Statue of Apollo
Roman, A.D. 100
Marble
H: 146.1 cm (57½ in.)
JPGM 85.AA.108
The feet of this STATUE and the hindquarters of the griffin at his side rest on top of the plinth, which would have fit into a similarly shaped cavity on the top of a BASE carved out especially for it and secured with molten LEAD. Photo: Lou Meluso.

PLINY

The Roman author (approximately A.D. 23–79) of *Natural History*, an encyclopedic account of contemporary knowledge. One of thirty-seven books comprising the work, Book 36 deals with stones, and stone sculptures and sculptors. *Natural History* is the principal source for the contents of public collections in Early Imperial Rome, listing twice as many Greek marble STATUES as bronze ones. Pliny also provides much technical information on WORKING STONE.

POINT (or PUNCH)

The TOOL used first for ROUGHING-OUT a block of quarried stone into the general shape and form of an intended STATUE. A length of square, rectanglar, or round-sectioned metal bar (ca. 15–22 cm, or 6–8.5 in., long) was hammered to a point at one end. Early sculptors used copper and then bronze points, but by about 470 B.C. hardened iron points were developed for use. When a point is held at right angles to the surface and tapped with a MALLET, it stuns the stone and flakes pieces off, leaving an indentation at the point of impact. A stone surface worked in such a manner with a point will have a network of small dimples where the flakes were struck off. When held at an oblique angle, short furrows are created on the stone if the tool is removed after each strike; long furrows remain if the point is struck in succession without lifting it from the surface of the stone. See also QUARRYING.

Point
Head of a Girl from
a Grave Monument
Greek, about 320 B.C.
Marble
H: 23.8 cm (9⅜ in.)
JPGM 58.AA.4
The hair on the back
of this girl's head has
been left roughened
with marks of the
point still visible.
Photo: Jack Ross.

POINTING

A method developed in the fifth century B.C. to transfer measurements from a MODEL to a stone being carved. For example, the PEDIMENT FIGURES of the Temple of Zeus at Olympia, dated about 460 B.C., bear traces of such measuring points. This practice, which was refined in later Greek and Roman times, left behind small protuberances on apparently finished STATUES— small points of reference to the original model or prototype. From the early first century B.C. pointing was used extensively to replicate statues; many Roman COPIES of Greek works were undoubtedly produced in this way. (See also illustration for MODEL, p. 69.)

POLISH

Using the method of ABRASION, marble was repeatedly rubbed to produce a smooth, shiny surface. To heighten the effect of the high degree of polish that could be achieved, Roman sculptors contrasted the polished areas with the roughly worked textures of hair, ancillary objects, and ATTRIBUTES.

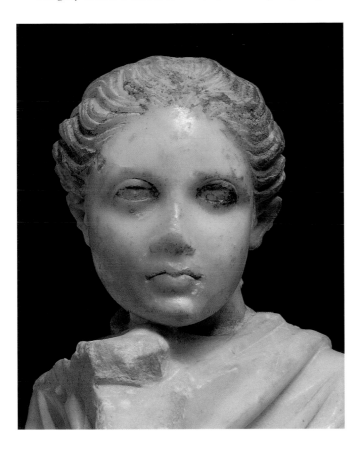

Polish
Statue of a Muse,
Melpomene or
Polyhymnia (detail)
Roman, about
A.D. 200
Marble
JPGM 94.AA.22
Some of the marble
of this STATUE has
been highly polished
to a glossy sheen. The
rough texture of the
locks of hair contrasts
with the smoothness
of the skin. (See also
illustration for
ENSEMBLE, p. 44.)

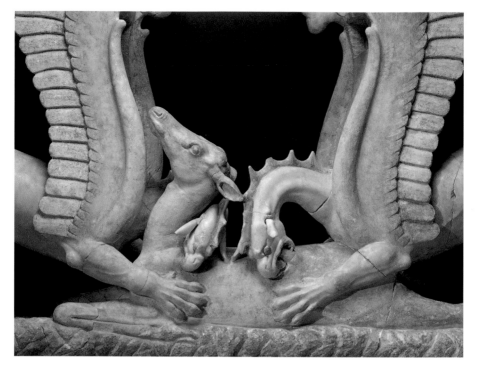

Polychromy
Sculptural Group (Table Support) of Two Griffins Attacking a Fallen Doe (detail).
Greek, about 325–300 B.C. Marble with polychromy. JPGM 85.AA.106
Remains of the bright colors once painted on this marble group can be seen on the combs of the griffins,
on their wings, and elsewhere. The vivid polychromy enhanced the naturalistic appearance of the animals.
Enough color remains today to appreciate the original colorful appearance of all ancient sculpture.

POLYCHROMY

A term that refers to the multicolored painting of sculptures. Most Egyptian,
Greek, and Roman sculpture was originally polychromed, as were buildings
such as the Parthenon on the Athenian Acropolis. Sculptures made of all ma-
terials—bronze, MARBLE, LIMESTONE, terracotta, and wood—were painted.
The principal colors were blue and red, but yellow, green, brown, black, and
white occur to a lesser degree. In marble sculpture of the ARCHAIC period,
color was applied to more limited areas than on sculpture of subsequent pe-
riods; it was usually confined to parts of the head and to the embroidered
bands and ornaments of clothing. On HELLENISTIC and Roman sculpture a
more extensive palette appears to have been used, adding subtler shading with
hues including purples and violets. Recent research on the remains of color
on Hellenistic sculptures reveals that color was applied in a series of TEMPERA
layers or washes. Areas of skin were often covered with a light, transparent

wash; in some periods, such as the Archaic, there are indications that the skin of women was left whitish, while that of men was painted brownish—color clearly denoting gender. See also PIGMENT.

POLYKLEITOS

The most admired sculptor of his era next to Pheidias, Polykleitos of Argos (Sikyon) worked from 450 to approximately 415 B.C. and was responsible for the Polykleitan SCHOOL of sculpture. He worked out a system of PROPORTIONS for the human figure called the CANON, which was illustrated by his famous *Doryphoros*, the STATUE of an athlete known only from Roman COPIES or versions of the original (see illustration for CANON, p. 21). All of his recorded sculptures but one were of bronze, but none survives. The few works ATTRIBUTED with certainty to Polykleitos are marble copies, often versions carved in the Roman period.

PORPHYRY

An igneous rock (cooled magma) that contains large, visible crystals in a fine-grained groundmass, porphyry comes from QUARRIES located in the eastern Egyptian desert (known today as Jebel Dokham) near Mons Porphyrites and Mons Igneus. Several varieties of porphyry are found at these sites: red to purple-red, green, and black. The stone is difficult to WORK, but its color, durability, and decorative effect when POLISHED was desirable. A fine-grained red or purple variety known as imperial porphyry was used in the Roman period for imperial commissions.

PORTRAIT

A likeness sculpted of a real person, living or dead—especially of the face. An ancient Greek or Roman sculpted portrait took the form of a BUST or a HERM, a seated figure, an EQUESTRIAN figure, a FREESTANDING STATUE, or a reclining effigy intended for a tomb. While portraits were intended to be visual likenesses, other elements were also important, especially for the Romans. The representation of virtuous aspects of character, spirituality, and social connections (such as family and class) were also considered. For example, portraits of Roman women were often more concerned with representing the latest notions of fashion and beauty than they were with depicting the actual features of the sitter. Some portraits were executed in RELIEF or intaglio, most notably on coins and gems. Coin portraits frequently had names inscribed on them and can be useful for identification when compared to unnamed but similar portraits in marble or bronze. Portraits of rulers and other eminent

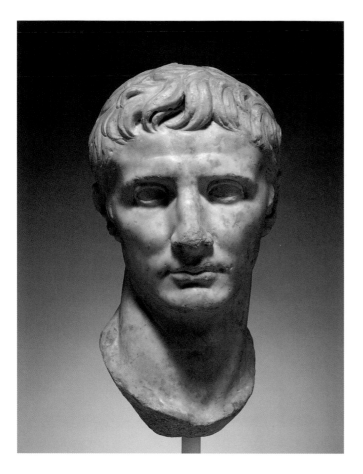

Portrait
Portrait Head of
Augustus
Roman, about A.D. 50
Marble
H: 39 cm (15⅜ in.)
JPGM 78.AA.261
Portraits of Augustus
served as symbols of his
political agenda more
than as representations
of his physical features,
which are described
in ancient literary
sources. Augustus
was always depicted
in portraits in an
ageless, IDEALISTIC,
CLASSICIZING manner.
The distinctive forked
locks of hair on his
forehead are a constant
feature of his portraits.

persons were frequently replicated in large numbers and distributed through-
out their respective kingdoms and empires. In spite of scholars' best efforts,
however, some portraits of individuals, known even in several COPIES or ver-
sions, remain anonymous. See also IDEALISTIC, VERISTIC.

PRAXITELES

An Athenian sculptor of works in both bronze and marble whose career cov-
ered the period from approximately 375 to 340 B.C. Renowned for his mar-
ble carving, his most famous work was the first nude female STATUE—the
Cnidian Aphrodite (see illustration for STRUT, p. 102). Praxiteles introduced
his own scheme of PROPORTIONS for representing the human body, and his
male figures are noted for their elegantly curved poses, relaxed appearance,
and overall impression of softness.

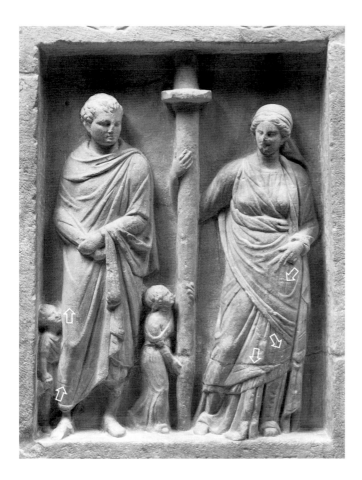

PRESS FOLDS

A term for the pattern of lightly carved lines on the clothing of sculpted figures to indicate that the fabric had been folded. The folding or storing of clothing symbolized a relatively high social standing and wealth of an individual: The person could afford more than one set of clothes.

PROCONNESIAN MARBLE

A medium- to large-grained MARBLE of both white and blue-gray varieties utilized in Roman times. It frequently appears as a white marble with distinctive blue-gray bands running either horizontally or vertically, depending on whether the piece of sculpture was carved with or against the horizontal pattern of the bands. QUARRIED on the island of Proconnesus (modern Marmara in Turkey), it was commonly used for SARCOPHAGI as well as other sculpture.

PROPORTIONS

The mathematical and geometric relationship of the parts of the human body and the ratio of each part or unit of parts to the whole figure. Proportions formed the underlying theory of sculptural design. The average human body is between seven and seven and a half times as tall as the height of its head, and the arm span is approximately equal to the height of a human figure. Plans for sculpting the ideal body, however, often divided the body into an evenly divisible number of parts. What the proportions of the human figure are—and/or what they should be—have been debated throughout the history of art.

Around 480 B.C. Pythagoras of Rhegion in South Italy is reported to have been the first sculptor to create naturalistic figures with clearly definable elements (*symmetria*) and regular proportions (*rhythmos*) (Diogenes Laertius 8.47). He defeated a rival sculptor, Myron, in two separate contests on proportion (Pliny *Natural History* 34.59). POLYKLEITOS published the CANON, which promoted the sculpting of figures according to an ideal set of proportions appropriate to each particular subject. Later, LYSIPPOS applied a new proportional system to the figure, reducing the size of the head and the arms to make his STATUES appear taller.

PROVENANCE

The origin, or source, of a material or a particular work of art. Currently in the study of sculpture, provenance most often refers to the QUARRY source of a particular marble. Determining the provenance of marble can often give an approximate date of the fabrication of a sculpture, information on trading patterns, insight into changing aesthetic tastes, and also shed light on authenticity. Provenance was determined by subjective means until recently. In the nineteenth century G. R. Lepsius was the first systematically to describe the major marble quarries of CLASSICAL times and to point out their general physical characteristics. This contribution was based solely on observation, for analytical methods for determining provenance had not yet been developed. Current analytical methods used to determine marble provenance include STABLE ISOTOPIC RATIO ANALYSIS, PETROFABRIC ANALYSIS, TRACE-ELEMENT ANALYSIS, and ELECTRON SPIN RESONANCE SPECTROSCOPY. Since no single available technique allows unambiguous or definitive distinctions between marble from major ancient quarries currently known, the combined information of different but complementary methods is needed to achieve a secure provenance.

PUMICE

The frothy upper layer of material of a lava flow is called pumice after it cools and hardens. Pumice is usually white, gray, yellowish, or brownish, but on occasion red. It is a lightweight volcanic glass—sharp edged when powdered—and therefore an ideal ABRASIVE for POLISHING stone and bronze sculptures. Greek sculptors used pumice found on the islands of Melos and Nisyros.

QUARRY

An open pit, a hillside opening, or an underground mine where naturally occurring stone, such as MARBLE, is extracted from the earth. Marble is formed in concentrated deposits and is naturally divided by faults. The blocks thus produced are not necessarily usable as complete blocks because they may have flaws. Finding perfect suitable blocks of marble is difficult and often requires a search by a quarry master, whose experience observing the face of the quarry allows him to identify the areas likely to yield the best blocks for sculptural use.

In carving a figure from a rectangular block of marble, the sculptor normally cut away stone at least equivalent to the bulk—and therefore weight—of the finished figure. Since weight was a critical factor in the cost of marble, it was cost-efficient to ROUGH- or BLOCK-OUT sculptures in quarries prior to transporting the marble to the sculptors' workshops. Even as early as the AR-CHAIC period figures were roughed-out in quarries to remove excess weight. After SPLITTING the rock (preferably along naturally occurring bedding layers) with PICKS and wedges, the GRID was marked on the block. The STATUE was then WORKED evenly all over with a POINT and MALLET, reducing its bulk to within a centimeter or two of the final surface, and only then readied for transport. See also TOOLS.

QUARRYING

The process of extracting stone from a QUARRY with TOOLS. Real quarrying started in Egypt during the period of the development of an architecture based on WORKED STONE (approximately 3100–2700 B.C.). During this same period sizable blocks of granite were also used for FREESTANDING STELAI. Apparently, the Egyptians invented the technique of isolating blocks from the parent rock by cutting narrow trenches all around them. For softer stones, such as SANDSTONE and LIMESTONE, these trenches were cut by means of copper POINTS whose edges had been hardened by hammering. Beginning about 1500 B.C. the copper points were replaced by stronger bronze points that left the traces of a herringbone pattern on quarry walls. Over time the tool became

longer and stronger and created long, oblique, almost parallel grooves. Iron was not used for quarry tools before the eighth or even the sixth century B.C.

Quarrying methods spread from Egypt throughout the Mediterranean world. The usual practice was to quarry on slopes where the cutting of blocks could be continued downward and outward, making transportation of the heavy stone and waste material much easier. Quarrying sometimes extended downward to considerable depths, eventually leaving a kind of stepped quarry face that showed traces of the instruments used to cut the trenches. Ptolemaic and Roman quarry faces worked by iron tools show a pattern of long, parallel groves. The Greeks appear to have quarried only particular consignments of MARBLE, with clearly specified dimensions for finishing; they may never have adopted the practice of accumulating already quarried and partly finished blocks or architectural elements as the Romans did. There was a reorganization of the quarry system in the Roman Imperial period during which quarries had to meet the requirements of mass production; the Romans built up enormous stocks of previously shaped material.

RADIOGRAPHY

The use of x-rays to image PINS, REPAIRS, and various technical features found in sculptures. Radiographs of marble sculpture help locate pinned JOINS.

Raking Light
Grave Stele of Philoxenos and Philoumene (detail)
Greek, about 400 B.C.
Pentelic marble
JPGM 83.AA.378
Raking light clearly reveals TOOL MARKS, surface deposits, and the letters of the INSCRIPTION in this detail of a sculpted marble grave monument.

RAKING LIGHT

A strong light source placed at an oblique angle to the surface of an object that often reveals TOOL MARKS and other features not noticeable in ambient or even artificial light. Examination of a sculpted object under raking light is routinely conducted during its assessment, especially to reveal the techniques and methods of its production.

RASP

Any of a number of FILE-like TOOLS with sharp raised points. Rasps are used to smooth the surface of stone sculptures, with evidence for their use appearing about 550 B.C. In addition to evening the general surface of a sculpture, they are used after FLAT or CURVED CHISELING and for fine shaping, such as on eyelids, nostrils, or lips. Rasps are excellent for working around forms of any size or shape and for getting into narrow and inconvenient places. The push and pull motion of the tool leaves a fine network of scratches on stone that overlap and go in all directions; only a thin layer of stone is removed with each stroke. Cf. SCRAPER.

Rasp
Portrait Head of a
Ruler (detail)
Greek, about 150 B.C.
Marble
JPGM 91.AA.14
Rasp marks are clearly
visible on the neck of
this PORTRAIT head.
(Cf. illustration for
CONSERVATION, p. 34.)
Photo: Anthony Peres.

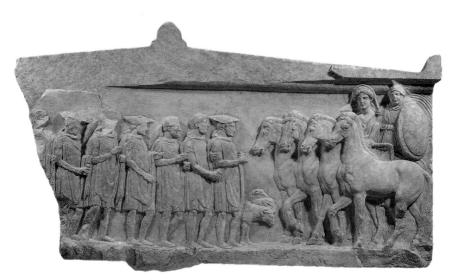

Relief
Votive Relief to Achilles and Thetis. Greek, about 350 B.C.
Marble. H: 78 cm (30¾ in.). JPGM 78.AA.264
On this Greek relief of the CLASSICAL period the sculptor has created the background as a
planar surface against which the figures are evenly displayed. Photo: Jack Ross.

RELIEF

A two-dimensional work in which carved figures project from a background
plane. Simpler than creating a STATUE IN-THE-ROUND, sculpting a relief re-
quires that only the front view—with a reserve of stone behind it—needs to
be carved. Reliefs are classified by the degree the carved figures project from
their background: In high relief the figures project at least half of their natu-
ral circumference from the background, whereas in low relief figures project
only slightly.

Greek and Roman sculptors approached the carving of reliefs from dif-
ferent viewpoints. There were generally four steps in the carving of Greek re-
liefs. An outline of the intended composition was drawn on the front face of
the stone. The outline was cut into the stone by reducing all around it down
to the background plane, which was generally flat and the same depth over
the entire relief. Once the background was carved, the sculptor used it as a
reference plane when next carving the figures. By contrast, unfinished Roman
sarcophagi of the second through fourth century A.D. demonstrate a different
approach. The intended scene was ROUGHED-OUT with a POINT. The point
was used to create spaces around the front figures without creating much
definition in the forms of the composition. Next a FLAT or CURVED CHISEL
was used to carve the details of each element of the design. There is no back-
ground as such, for the area between the figures was cut with a point with-

Relief

Front of a Sarcophagus. Roman, about A.D. 210. Marble. H: 54 cm (21 ¼ in.). JPGM 76.AA.8
There is no consistent background plane in this Roman relief of the Severan period. Instead each
figure or group of figures occupies its own space in the scene. Note the use of UNDERCUTTING.
Photo: Anthony Peres.

out taking away much stone. Details were then added behind the front figures, and the background was carved last. The background, therefore, is not a plane of its own, but rather the space that remains behind the figural scene. The plane of reference was always the front of the stone for the Roman sculptor—quite the opposite for his Greek counterpart.

REPAIR

Ancient sculptures have been found in archaeological CONTEXTS with signs of having been repaired in antiquity. In some cases broken surfaces were smoothed off and then worked with a POINT so that they would hold an ADHESIVE. In other instances holes were DRILLED and PIECES attached with PINS, clamps, or ties. Some objects have been found with patches of carefully cut marble; the JOINS of these patches would presumably have been disguised with a fill material and then painted.

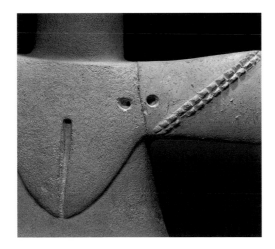

Repair
Statuette of a Female
Figure (detail)
Chalcolithic
(Early Bronze Age),
3000–2500 B.C.
Limestone
JPGM 83.AA.38
This figure's left arm
was broken and
repaired in antiquity.
Holes were DRILLED
on opposite sides of
the break and the
two pieces secured
by a staple or tie,
now missing.

REPLICA

An exact copy or duplicate of a work that is made the same size and in the same medium.

RESTORATION

Replacing missing parts and filling in missing areas, or restoring sculptures, has a long history. It was the vogue, especially during the eighteenth century, for young aristocrats to travel to Rome and throughout Italy to view ancient remains and purchase statuary for their homes and estates. The fashion was for complete—not fragmentary—STATUES. Since most ancient sculptures are fragmentary when found, restoring them to completeness developed into a business; one thriving example was centered in Rome, where Bartolomeo Cavaceppi was the leading restorer. The ancient fragments received newly carved additions in order to create whole figures and compositions. The fragments were reworked with POINTS, FLAT and CURVED CHISELS, DRILLS, and RASPS. They were then POLISHED with PUMICE, treated with acid to remove

OLD RESTORATIONS

ANCIENT
RESTORATION

ANCIENT
RECUT SURFACES

1996 RESTORATIONS

Restoration
Statue of Leda and
the Swan
Both ancient and
modern restorations
have been made to this
STATUE. The sculpture
underwent extensive
recent CONSERVATION,
which revealed the
restored areas, as
illustrated. (Cf.
illustration for
ATTRIBUTION, p. 16.)
Digital reconstruction
by Susan Lansing
Maish, Department
of Antiquities
Conservation, JPGM.

surface accretions (acquired from being buried), and antiqued with stains and false breaks to make the ancient and modern parts match. The primary aim was to produce an aesthetically pleasing result—not to embrace the authenticity of the ancient remains.

Modern methods of examination (by the use of ULTRAVIOLET LIGHT and by means of chemical, microscopic, and radiation analyses) can help sort out the ancient parts of a statue from these later—though now historical—additions. Restoration practices of the seventeenth through the nineteenth century often followed and mimicked ancient working methods, which has compounded the complexity of these restored sculptures. Current practice intentionally makes restorations more distinguishable from the ancient parts of a sculpture and far easier to recognize.

REUSE

The appropriation of sculptural material for another purpose or use. An example of reuse would be the appropriation of a damaged or neglected monument and the reworking of it for a second use (for example, certain Athenian grave STELAI of the fifth and fourth centuries B.C. were given new INSCRIPTIONS and rededicated in the Roman period). Reuse occurred on a larger scale with architectural sculpture than with individual STATUES. Once the Romans ruled the Mediterranean world, they transported back to Rome large numbers of Greek sculptures, including architectural members, for reuse in new Roman CONTEXTS. Some sculptures were recarved for new uses, mostly for the economy of the material, but they could also be reused for political reasons: Those emperors who conducted themselves dishonorably as rulers and were later condemned by the senate of Rome had their portraits recarved into the portraits of subsequent, more laudatory heads of state.

RICH STYLE

Sculpture carved in the last quarter of the fifth century B.C. that is characterized by figures whose clothing is layered fabrics of different weights and textures that often swirl about them in a dynamic pattern (see illustration for CLASSICAL DRAPERY: MOTION LINE, p. 30).

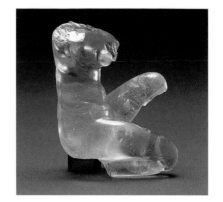

Rock Crystal
Statuette of Aphrodite
Greek, first
century B.C.
Rock crystal
H: 8.5 cm (3⅜ in.)
JPGM 78.AN.248
The use of a precious
material such as rock
crystal for this small
sculpture marks the
piece as an item of
luxury for a rich
patron.

ROCK CRYSTAL

A transparent quartz crystal of silicon dioxide. These crystals were carved into highly valuable gems and small sculptures.

ROSSO ANTICO MARBLE

An extremely fine-grained and compact MARBLE that ranges in color from a light red to a dark purple, with occasional black veins and white inclusions. It was QUARRIED in three places during antiquity: on Cape Tainaron (present-day Matapan on the Peloponnese of Greece), on Crete, and at the site of Iasos in Asia Minor. It was used during the MINOAN and MYCENAEAN periods and through the Roman period (when it was called *marmor Taenareum*). The height of its use was during Roman Imperial times when the marble was considered a precious stone because of its color. Like PORPHYRY, it is found in a purple hue—the color reserved for the clothing of the Roman nobility. Although sculptures were carved from this material, especially during the time of Emperor Hadrian (r. A.D. 117–138), its predominant use was for architectural elements of small size because it could only be quarried in relatively small blocks.

ROUGHING-OUT (or BLOCKING-OUT)

This first stage of producing a sculpture from a block of marble was generally done with pointed TOOLS such as PICKS and POINTS, often at the QUARRY site in antiquity. The block was reduced to a very rough form of the sculpture to reduce its weight prior to transporting it to a WORKSHOP for finishing.

Roughing-out

Lid of a Sarcophagus. Roman, about A.D. 180–220. Marble. L: 218 cm (85⅞ in.). JPGM 95.AA.80.2
As was common practice by Roman sculptors, the heads of the figures on the lid of a SARCOPHAGUS
were roughed-out and left unfinished so that they could be carved as PORTRAITS of the deceased when
the coffin was purchased. In this instance it is unknown why the portraits were never completed.

RUNNING DRILL

A sculpting TOOL to create a groove or channel of uniform width for many
uses, but especially for drapery folds. The sculptor drove the running drill
along the stone at an angle, pumping the bow or strap back and forth to keep
the drill rotating. These quick reversals of the direction of the drill produced

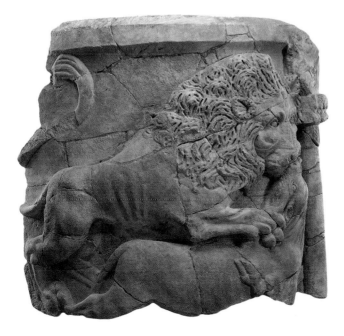

Running Drill
Fragment of a
Sarcophagus
Roman,
A.D. 375–400
Marble
H: 95.5 cm (37⅝ in.)
JPGM 78.AA.352
A running drill was
used to carve the
channels between the
strands of hair in the
mane of this lion.

distinctive scallop and gouge marks at the bottom of the groove. Evidence of the running drill first appears on sculptures dated to approximately 400 B.C. In the beginning the tool was used to subtly define contours or cut drapery grooves before final chiseling, but the technique replaced modeling with chisels by approximately 300 B.C. Cf. DRILL.

SANDSTONE

A sedimentary rock made up of sand that usually consists of quartz cemented by silica, iron oxide, or calcium carbonate. Coloration varies from shades of red, to yellow, brown, gray, or white. In a pulverized form it was used as an ABRASIVE agent to POLISH the surfaces of both bronze and MARBLE sculptures.

SARCOPHAGUS (pl. SARCOPHAGI)

A stone coffin, especially one with its exterior covered with RELIEF sculpture and INSCRIPTIONS. Sarcophagi were intended for public display. They advertised the wealth and social status of the deceased and his or her family by means of their size and the complexity and quality of their sculptures. An entire industry developed in the Roman Imperial period devoted to the QUARRYING, transport, and sculpting of marble sarcophagi. Since Romans favored certain common themes for sarcophagi, they were often bought ready-made. See also ROUGHING-OUT.

Sarcophagus
Sarcophagus. Roman, about A.D. 300. Marble. H: 59 cm (23¼ in.). JPGM 85.AA.30
Oval-shaped, this sarcophagus is decorated across the front with S-shaped fluted ornamentation in a vertical pattern. At either end a figure of Eros supports himself on an inverted torch, a symbol of mourning, and holds a garland in that hand. Fluted sarcophagi were popular in Rome, and a large number has survived.

SCHOOL

A group of artists working under the same influence, such as the sculptors working under POLYKLEITOS. Another school of sculpture was that of LYSIPPOS, active in the Early HELLENISTIC period.

SCRAPER

A TOOL with either a flat, curved, or toothed edge that is scraped back and forth across the surface of the stone to smooth and fine-shape a sculpture. It was a frequently used tool on Roman Imperial marble RELIEFS. With its flat cutting edge, the scraper left a smoother, less scratchy surface than the RASP. The toothed scraper was often used prior to the flat scraper, although it, too, was used as a finishing tool. Both the rasp and the scraper could be used on the same surface, but are easily distinguished from each other: The rasp produced a crisscrossed scratchy pattern, and the scraper left fine parallel lines (see illustration for DRILL, p. 41).

SEVERE STYLE (see EARLY CLASSICAL)

SHOULDER CORD

A band, apparently in the form of a figure eight, used at the shoulders to hold a dress from slipping down or out of place. The arms of the woman or girl went through the loops, with the crossing of the eight positioned at the back. It was commonly carved in the costume of active figures, such as charioteers, the goddess Artemis, and young girls.

Shoulder Cord
Grave Monument
of Demainete
Greek, about 310 B.C.
Marble
H: 96.5 cm (38 in.)
JPGM 75.AA.63
Shoulder cords can
be seen on the right
shoulders (arrows) of
both Demainete and
the smaller attendant.
The cords hold the
dresses of the two girls
in place and emphasize
their youthful ages.
Photo: Jack Ross.

SIGNED

A term that refers to the fact that a sculpture has the signature of its maker or artist. See also BASE, INSCRIPTION.

SOCKET AND TENON

A type of JOIN used to PIECE together parts of a sculpture. The end of one part of a sculpture was shaped as a tenon, or protrusion, and a socket, or cavity, was carved in the corresponding part; they were then fitted together. Molten LEAD was channeled into the space left between the socket and tenon through a hole DRILLED from the backside. Finally, an iron PIN was inserted through a second hole to completely fasten the join.

Socket and Tenon
Right Arm from the
Statue of a Goddess
(detail)
Greek, 425–400 B.C.
Marble
JPGM 88.AA.76
A deep, rectangular
socket has been carved
in the end of this arm
of the colossal STATUE
of a goddess; a
similarly shaped tenon

was carved on the body
of the figure. The parts
were held together by a
PIN, which was inserted
through a round hole
in the side of the arm—
barely discernible on
the right side of the
socket. (Cf. illustration
for CLASSICAL
DRAPERY: MOTION
LINE, p. 30.)

SPLITTING

A method used both in QUARRYING and in paring down a rough block of stone to the right dimensions for a sculpture. In antiquity stone blocks were split away from the QUARRY face through the pressure applied within faults or cracks from wood that was soaked (and which consequently expanded), or hammered iron wedges that were positioned in a straight line.

STABLE ISOTOPIC RATIO ANALYSIS

Isotopic ratios of oxygen and carbon vary in different rocks depending on their geological histories. (An isotope is any of two or more forms of a chemical element that have the same number of protons in the nucleus, but different numbers of neutrons.) Analysis of the stable isotopic ratios of oxygen and carbon in a specific MARBLE sample can help to identify the particular QUARRY, or the PROVENANCE, from which the sample was extracted. These ratios produce distinct signatures for many CLASSICAL Greek and Roman quarries. By means of these data, the marble of many INSCRIPTIONS and STATUES has been related to its quarry source. Stable isotopic ratio analysis has

also proven useful in associating broken fragments of marble sculptures. An isotopic database of marble samples from the major ancient quarries of Greece, Turkey, Italy, and Tunisia now permits sourcing of artifacts. Some of the signature fields of the different quarries overlap, however, and additional analytical methods, such as ELECTRON SPIN RESONANCE SPECTROSCOPY, must be used to distinguish sources.

STATUE

A carved or modeled three-dimensional figure (especially of a person or animal). A statue is a figure that is more than half LIFE-SIZE, as opposed to a STATUETTE, which is less than half LIFE-SIZE.

STATUETTE

Any carved or modeled figure that is half or less than half LIFE-SIZE; sometimes called a figurine. See also STATUE.

STEATITE

A kind of grayish-green, tan, or brown soapstone, steatite is soft and relatively easy to cut with sharp TOOLS. Found on the island of Crete, it was used extensively by the MINOANS. It was also popular in the Roman period, especially for STATUETTES of Egyptian figures, often divinities.

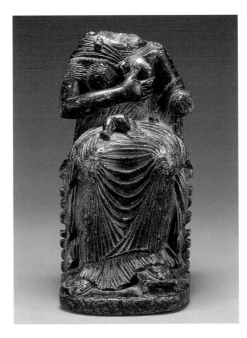

Steatite
Statuette of Isis
Roman, 100 B.C.–
A.D. 100
Steatite
H: 18 cm (7⅛ in.)
JPGM 79.AA.218
This STATUETTE represents the goddess Isis, seated and nursing the infant Harpokrates. Isis was a powerful Egyptian goddess of motherhood and magic. She is dressed in the customary garments of an Egyptian: fringed shawl knotted between her breasts over a CHITON and HIMATION.

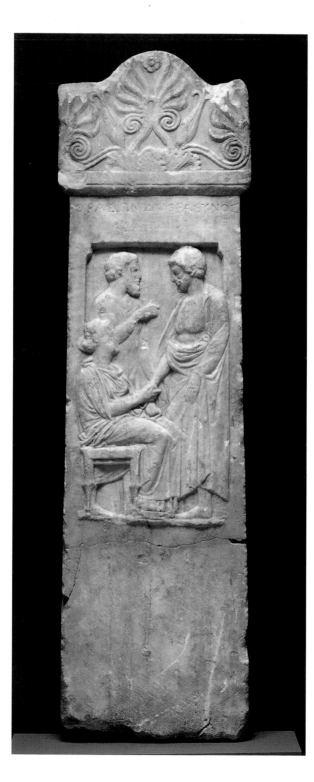

Stele
Grave stele of
Thrasynos
Greek, about 375 B.C.
Marble
H: 139.1 cm (54¾ in.)
JPGM 72.AA.120
The tall narrow
form of this stele
and the design of its
ANTHEMION help to
date this monument:
It was carved early in
the series of stelai used
in the LATE CLASSICAL
period and retains
much of the period's
basic slablike form.

STELE (pl. STELAI)

An upright rectangular wooden or stone slab used most commonly to mark burials and graves. A stele might be INSCRIBED as a dedication, commemoration, or legal proclamation (decree).

STOLA

A full-length garment worn over a TUNIC by Roman women, the stola was usually sleeveless. The back and front were fastened by pins or brooches or sewn together at the shoulders. It was made either by bunching the cloth at the shoulder or by cutting or weaving the fabric into a more narrow shape at the shoulder. The garment was worn by Roman matrons to signal that they had married.

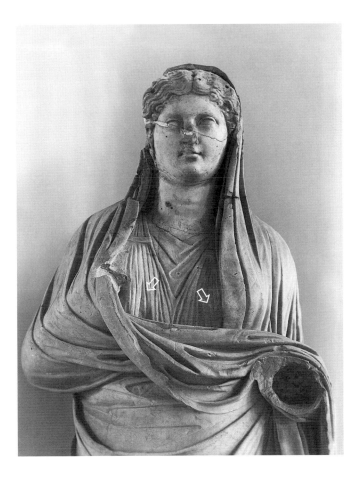

Stola
Woman Wearing a Stola (detail)
Roman, A.D. 1–25
Marble
Rome, Museo Nazionale Romano
121216
The flat strap of the stola can be seen on the right shoulder of this Roman matron. She is also wearing a TUNIC under the stola and a PALLA over it. Photo: Sansaini, for DAI, Rome, neg. no. 56.232.

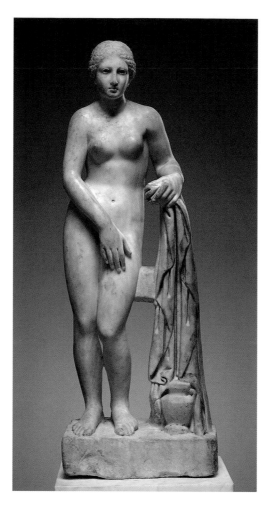

STRUT

A bridgelike section of marble left between a body and its extremities, the strut was a common feature of Roman sculpture. Although their purpose may have been to support an arm or leg positioned in space, struts seem to have taken on a stylistic and aesthetic function as well.

STUCCO

A type of plaster composed of lime or gypsum, sand, and pebbles or other aggregate. In localities where marble was scarce, such as Egypt, stucco was sometimes used to supplement the marble to complete a sculpture. When hardened, it could be carved and shaped like stone.

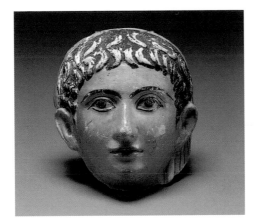

Stucco
Mask of a Youth
Romano-Egyptian,
first century A.D.
Stucco with
polychromy
H: 15 cm (5⅞ in.)
JPGM 71.AI.365
This PORTRAIT of a
young man was carved
from easily worked
stucco; the hair and
features are painted.

SUPPORT

A sculpted object attached to the lower legs of a STATUE in order to strengthen and stabilize the figure. Roman STATUES commonly had supports carved in the shape of a tree trunk.

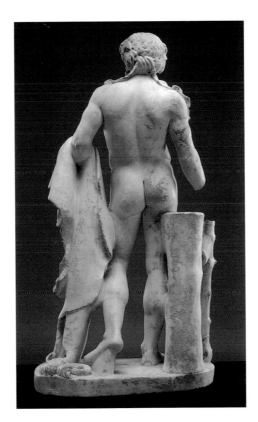

Support
Statue of Hercules
Roman, second
century A.D.
Marble with
polychromy
H: 116.8 cm (46 in.)
JPGM 73.AA.43
The tree trunk
attached to the right
leg of Hercules acts
as a support for the
lower part of his figure.
In addition, the lion
skin draped over his left
arm is attached at two
points to his left leg,
further strengthening
the figure.

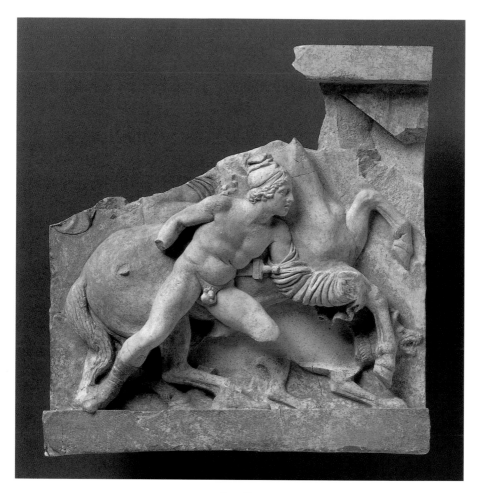

Tarantine

Fragment of a Funerary Relief. Greek, about 300 B.C. Limestone with polychromy.
H: 37.5 cm (14¾ in.). JPGM 74.AA.7
This example of high RELIEF is part of a hunting scene and is only a section of a larger sculptural
program that decorated a funerary monument in the shape of a miniature temple. Tarantine sculptors
were highly accomplished, as the fine quality of the sculpting on this relief clearly illustrates. The
conception, design, and execution of the relief's composition are synthesized in
the finest tradition of ancient Greek sculpture.

TARANTINE

A term that refers to the center for stone working in the Greek colony of
Taras in South Italy, which flourished during the fourth and third centuries
B.C. Exploiting both local LIMESTONE and imported Greek MARBLE, Taran-
tine sculptors created architectural as well as FREESTANDING sculpture. Battle
and hunting scenes, mostly of mythological origin, were popular subjects for
these artists.

TEBENNA

A semicircular piece of fabric predating the Roman toga, the tebenna was fashioned into an article of clothing worn by Etruscan men. It was wrapped around the hips with one end of the long garment pulled over one shoulder, leaving the other bare. The tebenna was often patterned along its edges.

TEMPERA

Water-based paint made by combining PIGMENT with a BINDER of raw egg, tempera produces an opaque paint surface with a soft sheen. See also POLYCHROMY.

THASIAN MARBLE

White MARBLE of both the calcitic and DOLOMITIC types QUARRIED on the island of Thasos in the northern Aegean. Very coarse-grained calcitic marble was found at Aliki, and was used for sculpture. Uniformly white dolomitic marble, with medium- to large-sized grain and exceptionally large glittering crystals, was found at Saliari and Cape Vathy, and was popular in the Roman period for sculpture, architecture, and SARCOPHAGI. Since Thasian dolomitic marble is harder than calcitic marble, it was more difficult to sculpt. Additional QUARRY sites for calcitic marble were found on the acropoles of Limenas, Cape Faneri, Pyrgos, Pholia, and Archangelou. Quarrying for both types commenced in the seventh century B.C. and continued until the time of the Slavic invasions at the beginning of the seventh century A.D. The second century A.D. was the main period of use for Thasian dolomitic marble in Rome and the surrounding area.

THIN-SECTION MICROSCOPY

A technique used to differentiate between the MARBLES of different QUARRIES in various locations. The main and accessory minerals in rocks can be identified by examining thin sections of them with the aid of a polarizing microscope; this same instrument is used to study the texture and to determine the maximum grain size [MGS] of calcite. A stain such as alizarin red S can be applied to the thin sections to distinguish between calcitic and DOLOMITIC marble.

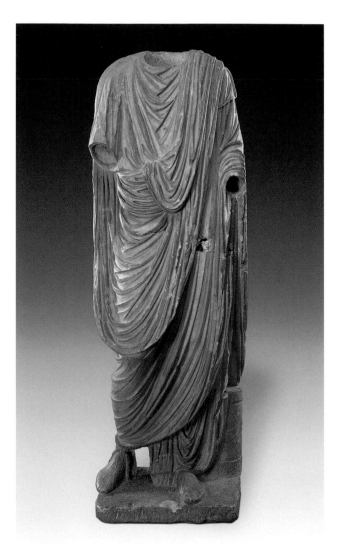

Togatus
Statue of a Togatus
Roman,
A.D. 150–200
Marble
H: 152 cm (59⅞ in.)
JPGM 79.AA.77
A voluminous toga
enfolds this standing
man. A PORTRAIT head
of a prominent Roman
would have been
INSERTED into the neck
cavity of this STATUE.
This type of portrait
statue was popular
because the toga
reflected a man's social
status. This man also
wished to be perceived
as well read: note the
CAPSA partially hidden
behind his left foot.

TOGATUS

A common type of STATUE of a man wearing a toga from the Roman period.
The toga was the garment most closely associated with the Romans. Originally
only a common item of clothing, the toga came to have symbolic meaning. By
the beginning of the first century A.D. the toga had become a ceremonial gar-
ment that denoted men's status in society. When conducting public business,
for example, men always wore a toga, and by order of the emperor Augustus
all citizens were required to don a toga when in the forum. By the middle of
the first century A.D. the toga was the means of distinguishing citizenship—
only Roman citizens could wear the toga, noncitizens could not.

TOOLS

Handheld equipment used to cut, shape, and finish stone sculptures. Tools to create sculptures include: FLAT, CLAW, and CURVED CHISELS; COMPASSES; DRILLS; DROVES; FILES; MALLETS; PICKS; POINTS; RASPS; RUNNING DRILLS; and SCRAPERS. Sculptures were originally formed by tools made from other, harder stones, such as EMERY and OBSIDIAN; during antiquity the composition of tools changed to copper alloys, then bronze, and finally iron; they changed little in form until the development of modern power tools. Although not strictly tools, the finishing of sculptures often requires the use of ABRASIVES, such as sand and PUMICE, for POLISHING.

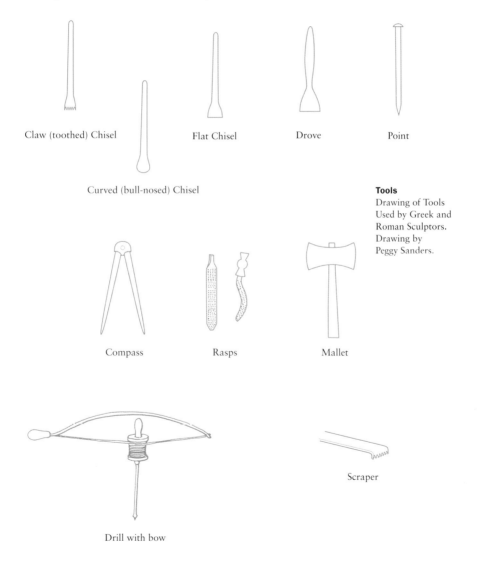

Claw (toothed) Chisel

Flat Chisel

Drove

Point

Curved (bull-nosed) Chisel

Tools
Drawing of Tools
Used by Greek and
Roman Sculptors.
Drawing by
Peggy Sanders.

Compass

Rasps

Mallet

Drill with bow

Scraper

TOOL MARKS

Distinctive markings on marble and other stone made by the TOOLS used for sculpting. See also CLAW CHISEL, CURVED CHISEL, DRILL, FLAT CHISEL, POINT, RASP, RUNNING DRILL, and SCRAPER.

TORSION

A pose of twisting motion that grew to be favored for the sculpture of the HELLENISTIC and Roman periods. When a figure is sculpted in the motion of turning its body around its central axis, the viewer is invited to imagine or actually walk around the sculpture. Torsion creates a sense of animation and dynamism in the figure.

Torsion
Fragment of a Statue of Actaeon. Roman, A.D. 150. Marble. H: 65 cm (25 ⅝ in.). JPGM 72.AA.110
Although only a fragment of this STATUE is preserved, the torsion of Actaeon's body is clear:
The musculature between his chest and abdomen is twisted in a writhing pose to indicate the
tormented action of this mortal figure who was being torn apart by his hounds after watching
the goddess Artemis bathing.

TRACE-ELEMENT ANALYSIS

The concentration of various trace elements can be used to determine the PROVENANCE of MARBLE. Marbles from different QUARRIES contain varying amounts of trace elements (minute concentrations of the elements). A variety of analytical tests for measuring the trace-element abundances in marble have been tried (including chemical analysis, instrumental neutron-activation analysis, atomic-absorption spectrometry, and colorimetry), but many trace elements vary by factors of over a hundred within the same quarry. Recently, multivariate statistical treatment of trace-element data has shown great promise for overcoming the inherent variability in the composition of marbles. Although not yet a completely viable analytical technique, it should become more useful in the future with increased accumulation of databases for trace elements.

TUFA

A coarse stone historically but erroneously believed to be concreted volcanic dust. It is, in fact, a porous microcrystalline LIMESTONE, composed almost entirely of calcium carbonate. It is widely available in Italy and was used there in antiquity for sculpture and architecture.

Tufa
Acroterion in the Form of a Gorgon with the Features of Alexander the Great
Etruscan, about 280 B.C.
Tufa
H: 51 cm (20⅛ in.)
JPGM 78.AA.10
The head of this ACROTERION would have formed the apex of a PEDIMENT on a small building. The coarseness of tufa lends itself to large-scale sculpted architectural elements such as this one.

TUNIC

The basic garment worn by Romans, usually underneath a toga, a PALLA, or a STOLA. In Greece it was worn only by young men and boys. The length of the tunic varied: about midthigh for children and slaves, midcalf for men, and ankle- or full-length for women. The basic construction for a woman's tunic was from one large rectangular piece of fabric or two rectangles of fabric held horizontally, sewn at the sides to the underarms and then either sewn, pinned, or buttoned over the shoulders and upper arms. Men's tunics were constructed from a large rectangular piece of fabric held lengthwise with a head opening cut or woven at the center and the sides sewn together from hem to underarms. The male tunic could also have simple sleeve extensions either woven or sewn onto each side of the fabric. The tunic was generally belted, although when an individual was in mourning or engaged in religious practice, it was left unbelted. (See also illustrations for ANTHEMION and HERAKLES KNOT, pp. 9, 51.)

Tunic
Funerary Monument with a Reclining Girl (detail)
Roman, A.D. 120–140. Marble (detail). JPGM 73.AA.11
The girl on this Roman funerary monument wears a tunic buttoned at the sleeve seam,
visible on her right arm (arrow).

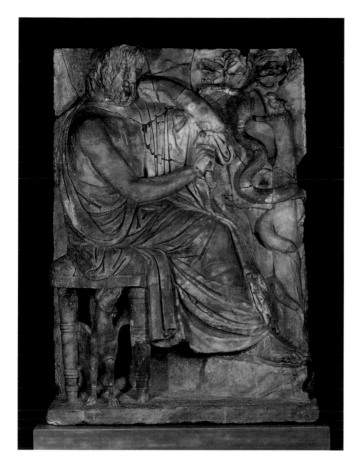

Ultraviolet Light
Grave Monument
of a Seated Man
Greek, about 75 B.C.
Marble
H: 143.5 cm (56½ in.)
JPGM 72.AA.160
Examination of this
gravestone under
ultraviolet light helped
to determine more
recently RESTORED
areas from ancient
original parts. Photo:
Lou Meluso.

ULTRAVIOLET LIGHT

Because freshly broken or cut marble fluoresces differently than older worked
surfaces, marble sculpture examined or photographed under ultraviolet light
can reveal the difference between older worked surfaces and more recent
carving. This technique can be valuable in answering questions regarding
possible recarving, the relative age of some damage, and the authenticity of
a sculpture. Ultraviolet-light inspection can also be useful when comparing
the ALTERATION, or WEATHERING, that different objects have undergone—
ancient surfaces fluoresce amber (sometimes mottled with purple), while
fresh or modern surfaces fluoresce light purple with no amber coloration. The
technique is useful in determining JOINING surfaces, REPAIRS, and modern
reconstructions, but for the authentication of a particular sculpture, it must
be used in conjunction with other more quantitative geochemical techniques.
See also PROVENANCE.

UNDERCUTTING

The DRILL was used in sculpting RELIEFS to cut out (or undercut) the stone behind figures in order to make them stand out against the background or against adjacent figures. A large drill that left a hole approximately 1 cm (⅓ in.) in diameter was commonly used for separating such figures from the background plane. (See illustration for RELIEF, p. 90).

VERISTIC

A veristic portrait of an individual is one that attempts to realistically show the person as he actually appeared in life. Etruscan and Republican Roman PORTRAITS were very naturalistic, including details of the sitter's physiognomy and figure—whether beautiful or ugly. See also IDEALISTIC.

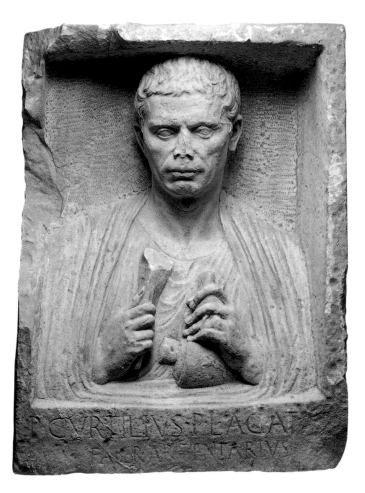

Veristic
Grave Relief of Publius Curtilius
Roman, A.D. 1–25
Marble
H: 79.9 cm (31½ in.)
JPGM 96.AA.40
The INSCRIPTION reads "P[ublius] Curtilius, freedman of Publius, silversmith." The PORTRAIT of this former slave was rendered with his individual features, and he is shown in a lifelike manner fashioning a small cup with the tools of his craft; it is a veristic portrait. Photo: Bruce White.

VOTIVE OBJECTS

Many ancient works of art were made as offerings to gods and goddesses or heroes. While some works were made from expensive material by the most highly regarded artists of the day, many more were produced of lesser quality and cheaper materials. All sorts of objects, including sculptures from marble to terracotta, might be dedicated at sanctuaries—places consecrated to particular gods. Surviving inventories from the Parthenon—the temple of Athena on the Acropolis in Athens—record that the temple was filled with such offerings.

Whatever the object was, central to the dedication was a sense of reciprocity: The votive object was presented with the expectation of something in return (e.g., success in battle, health, finding a spouse, etc.). Many surviving dedicatory INSCRIPTIONS reveal a tone of contractual agreement between deity and dedicator.

WAX

Also called beeswax, this plastic substance secreted by bees is used to construct their honeycombs. All waxes melt at less that 100°C (212°F, or the boiling point of water) and can therefore be liquefied in boiling water. Pliny (*Natural History* 33.122, 35.149) described the use of wax in ancient ENCAUSTIC painting. Wax has also been found in ADHESIVE mixtures through analysis.

WEATHERING (or ALTERATION) LAYER

The term refers to the complex layers that form over time on stone surfaces during burial or aboveground exposure; collectively, these layers are known as patina. The weathering of rocks involves both physical and chemical factors, among which are the work of organisms such as lichens, cycles of heat and cold, and the effects of water. Although the composition of weathering layers differs from artifact to artifact, common to all is that they are very distinct from the underlying rock substrate. The manifestation of weathering layers on marble and other stone artifacts is a function of the crystal size, mineralogy, rock type, weathering history, RESTORATION, and cleaning techniques that might previously have affected the object. A study of the alteration layer(s) of ancient archaeological artifacts, such as marble sculptures, can assist in determining age, PROVENANCE, and authenticity. Geochemical and petrographic techniques, similar to those used in geological investigations of any other rock weathering and mineral alteration, can be used in these determinations.

Working [stone]

Working stone requires that its physical characteristics (its composition and hardness, WEATHERED condition, flaws, etc.) respond to the action of carving TOOLS. While some stones are essentially unworkable, certain stones can be carved with difficulty, and still others can be carved easily and in fine detail (e.g., LIMESTONE and STEATITE are easy to work, whereas DOLOMITIC and NAXIAN MARBLES and BASALT are difficult to carve or work).

Workshop

Sculptors, apprentices, and craftsmen created sculptures in workshops. Ancient sculpture production was a craft learned through an apprenticeship. A master sculptor would head a workshop and teach the craft to others. A passage in Plato (*Protagoras* 328A) suggests that workshops were usually family operations. A modest marble-working business could be maintained by a man, his son, and a slave. Where archaeological evidence of ancient sculpture production has been excavated, it seems that these were often temporary operations set up to complete specific commissions.

Master sculptors in Greece do not seem to have been slaves, which is implied by their mobility, inclusion of their ethnicity in SIGNED work, their connections to noble families, and their election to magistracies and priesthoods. The Romans, however, later enslaved Greek artisans who were taken captive. In general, during the Roman period sculptors were considered to be common craftsmen and were held in low esteem because they worked with their hands. According to Plutarch (*Life of Pericles* 2) ". . . a man who occupies himself with servile tasks proves by the very pains which he devotes to them that he is indifferent to higher things. No young man of good breeding and high ideals feels that he must be a Pheidias or a Polykleitos after seeing the statue of Zeus at Olympia or Hera at Argos, . . . for it does not necessarily follow that because a particular work succeeds in charming us its creator also deserves our admiration." See also ARGIVE, ATHENIAN, and IONIAN WORKSHOPS.

X-RAY

A form of electromagnetic radiation (similar to light but of a shorter wavelength) that is capable of penetrating solids. Examination of stone sculptures by x-rays can reveal the number and location of metal PINS used to JOIN PIECES of marble together. See also RADIOGRAPHY.

X-RAY DIFFRACTION SPECTROMETRY

A technique that determines the crystalline structure of materials, both metal and stone. It is used to distinguish between DOLOMITIC and calcitic MARBLE and requires only a small sample of marble powder. When x-rays hit a marble sample, a portion of the x-rays are diffracted by the regular crystal structure. These diffracted x-rays produce a pattern of lighter and darker lines on film. The pattern depends on the composition of the sample and, by reference to standard data, this pattern can be used as a kind of "fingerprint" to identify the sample.

Chart of Greek and Roman Garment Types

FEMALE

CHITON

CHITON, fabric folded and side sewn

CHITON, fabric folded, sewn and buttoned

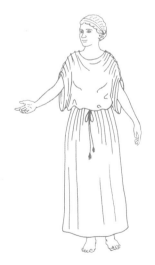

CHITON, fabric folded gathered and belted

DIPLAX, fabric folded

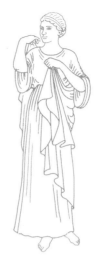

DIPLAX, worn over CHITON

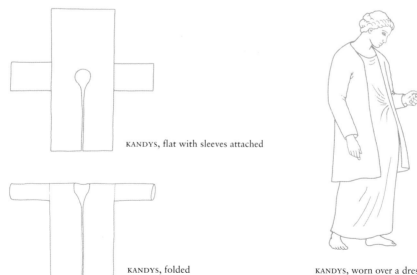

KANDYS, flat with sleeves attached

KANDYS, folded

KANDYS, worn over a dress

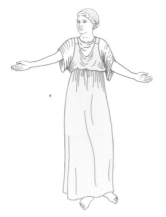

STOLA, worn over a TUNIC

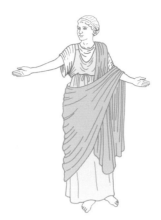

PALLA, worn over a STOLA and a TUNIC

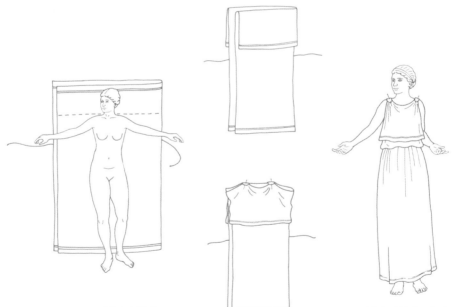

PEPLOS, fabric folded

PEPLOS, fabric folded and pinned

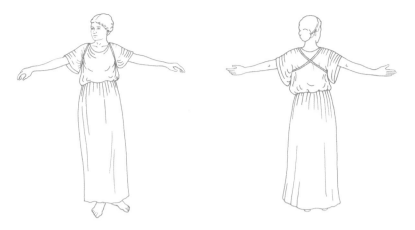

Shoulder cords, worn over a chiton

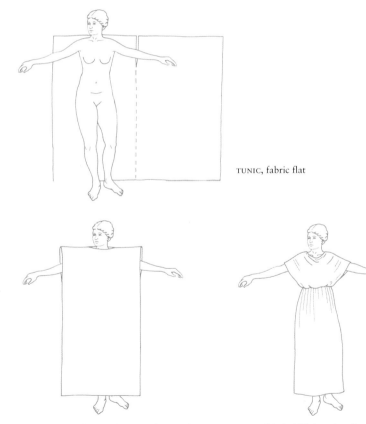

Tunic, fabric flat

Tunic, fabric folded and sewn or buttoned

Tunic, fabric folded, gathered, and belted

MALE

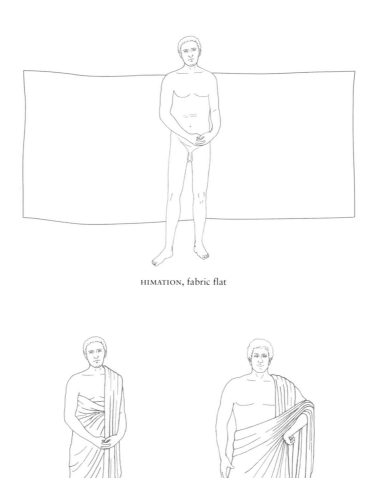

HIMATION, fabric flat

HIMATION, draped in two different ways

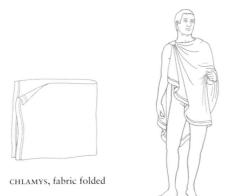

CHLAMYS, fabric folded

CHLAMYS, fabric folded and fastened

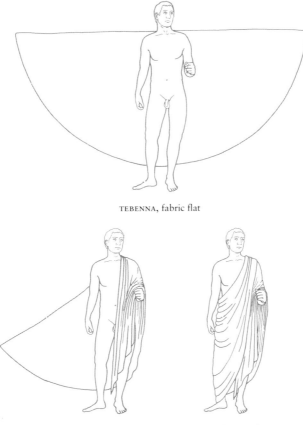

TEBENNA, fabric flat

TEBENNA, fabric draped partially (left) and fully (right)

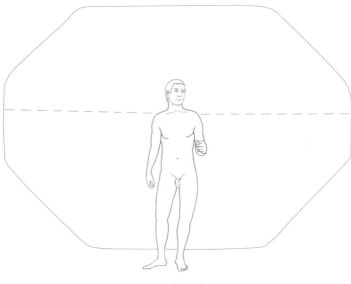

TOGA, fabric flat

TOGA, fabric folded

TOGA, fabric folded and partially draped

TOGA, fabric folded and fully draped

TUNIC, fabric flat with sleeves sewn on

TUNIC, fabric folded

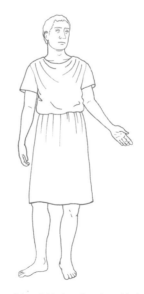

TUNIC, fabric folded, gathered, and belted

Select Bibliography

ADAM, S. *The Technique of Greek Sculpture in the Archaic and Classical Periods.* London, 1966.

DODGE, H., and J. B. WARD-PERKINS, eds. *Marble in Antiquity: Collected Papers of J. B. Ward-Perkins.* London, 1992.

DURNAN, N., "Stone Sculpture." In *Making Classical Art: Process and Practice*, ed. R. Ling, pp. 18–36. Charleston, 2000.

GINOUVÈS, R., and R. MARTIN. *Matériaux, techniques de construction, techniques et formes du décor.* Vol. 1 of *Dictionnaire méthodique de l'architecture grecque et romaine.* Paris and Rome, 1985.

GNOLI, R. *Marmora romana*, 2nd edn. Rome, 1988.

HÄGER-WEIGEL, E. M. *Griechische Akrolith-Statuen des 5. und 4. Jhs. v.Chr.* Berlin, 1997.

HERRMANN, JR., J. J., N. HERZ, and R. NEWMAN, eds. *Interdisciplinary Studies on Ancient Stone.* ASMOSIA, vol. 5. London, 2002.

HERZ, N., and M. WAELKENS, eds. *Classical Marble: Geochemistry, Technology, Trade.* ASMOSIA, vol. 1. Dordrecht, London, Boston, 1988.

KORRES, M. *The Stones of the Parthenon.* Los Angeles, 2000.

MANIATIS, Y., N. HERZ, and Y. BASIAKIS, eds. *The Study of Marble and Other Stones Used in Antiquity.* ASMOSIA, vol. 3. London, 1993.

PAUSANIAS. *Description of Greece.* Ed. and trans. W. H. S. Jones. Cambridge, MA (Loeb Classical Library), 1918–1935.

PLINY THE ELDER. *Natural History*, Books 34–36. Ed. and trans. H. Rackham and E. E. Eichholz. Cambridge, MA (Loeb Classical Library), 1952, 1962.

POLLITT, J. J. *The Art of Greece 1400–31 B.C.: Sources and Documents.* Englewood Cliffs, NJ, 1965.

POLLITT, J. J. *The Art of Rome ca. 753 B.C.–A.D.337: Sources and Documents.* Englewood Cliffs, NJ, 1983.

REUTERSWÄRD, P. *Studien zu Polichromie der Plastik: Griechenland und Rom, Untersuchungen über die Farbwirkung der Marmor- und Bronzeskulpturen.* Stockholm, 1960.

RIDGWAY, B. S. "Stone Carving: Sculpture." In *The Muses at Work: Arts, Crafts and Professions in Ancient Greece and Rome*, ed. C. Roebuck, pp. 96–117. Cambridge and London, 1969.

ROCKWELL, P. *The Art of Stoneworking: A Reference Guide.* Cambridge, 1993.

SCHVOERER, M., ed. *Archéomatériaux: Marbres et autres roches: Actes de la IVème conférence internationale de l'association pour l'étude des marbres et autres roches utilisés dans le passé.* ASMOSIA, vol. 4. Bordeaux, 1995.

TRUE, M., ed. *Color in Ancient Greece: The Role of Color in Ancient Greek Art and Architecture 700–31 B.C.* Thessalonike, 2002.

TRUE, M., and J. PODANY, eds. *Marble: Art Historical and Scientific Perspectives on Ancient Sculpture.* Malibu, 1990.

VAN VOORHIS, J. A. "Apprentices' Pieces and the Training of Sculptors at Aphrodisias." *Journal of Roman Archaeology* 11 (1998): 175–92.

VON GRAEVE, V., and F. PREUSSER. "Zur Technik Griechischer Malerei auf Marmor." *Jahrbuch des Deutschen Archäologischen Instituts* 96 (1981): 120–56.

WAELKENS, M., N. HERZ, and L. MOENS, eds. *Ancient Stones: Quarrying, Trade and Provenance: Interdisciplinary Studies on Stones and Stone Technology in Europe and the Near East from the Prehistoric to the Early Christian Period.* ASMOSIA, vol. 2. Louvain, 1991.

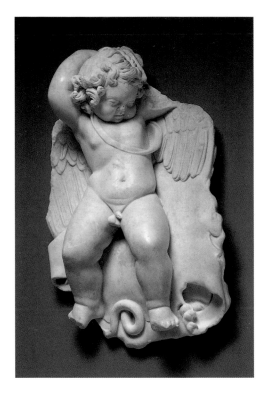

Louise D. Barber, *Manuscript Editor*

Benedicte Gilman, *Editorial Coordinator*

Elizabeth Chapin Kahn, *Production Coordinator*

Kurt Hauser, *Designer*

Ellen Rosenbery, *Photographer*
(JPGM objects, unless otherwise noted)

David Fuller, *Cartographer*

Typeset by G&S Typesetters, Inc.

Printed by Imago